# THE ESSENTIAL™

# Frank O. Gehry

**BY LAURENCE B. CHOLLET**

THE WONDERLAND PRESS

Harry N. Abrams, Inc., Publishers

**THE WONDERLAND PRESS**

The Essential™ is a trademark
of The Wonderland Press, New York
The Essential™ series has been created by The Wonderland Press

Series Producer: John Campbell
Series Editor: Harriet Whelchel
Project Manager: Adrienne Moucheraud
Series Design: The Wonderland Press/Marc van Schendel

Library of Congress Control Number: 2001087910
ISBN 0-8109-5829-5 (Harry N. Abrams, Inc.)

*On the end pages:* Disney Ice Rink. 1993–95. Anaheim, California

Printed and bound in Hong Kong

**PHOTOGRAPH CREDITS:**
AFP/CORBIS 100; Paul Almasy/CORBIS 20; Bettmann/CORBIS 9 (bottom right), 48, 62 (top); Leslie Brenner/ESTO End pages; Richard Bryant/ARCAID 71, 73, 82 (top & bottom left), 84 (right); Cartoon Bank/Condé Nast 16; Geoffrey Clements/CORBIS 29 (bottom); Colin Dixon/ARCAID 77; Alfred Eisenstadt 9; Frank O. Gehry and Associates 47, 86–87; Jeff Goldberg/ESTO 64 (top); Tim Griffith/ESTO 80–81; Guggenheim Museum, Bilbao 95. 97; David Heald © SRGF, NY 6 (bottom right). 111; John Edward Linden/ARCAID 60, 102; Luckhaus Studio, L.A. 17 (top); Thomas Mayer/Das Fotoarchiv 4, 24, 35, 38, 49, 69, 72, 76, 78, 82 (right), 89, 93, 94, 96–97, 98, 99, 106–107, 108–109; Roger Ressmeyer/CORBIS 6 (bottom left), 51, 54, 55; Julius Shulman 17 (bottom); Ezra Stoller/ESTO 65; Tim Street-Porter/ESTO 42, 43, 57; Lara Swimmer/ESTO 66 (bottom), 103, 104, 105; Natalie Tepper/ARCAID 85; Ruggero Vanni/CORBIS 67; Patrick Ward/CORBIS 21.

Harry N. Abrams, Inc.
100 Fifth Avenue
New York, NY 10011
www.abramsbooks.com

# Contents

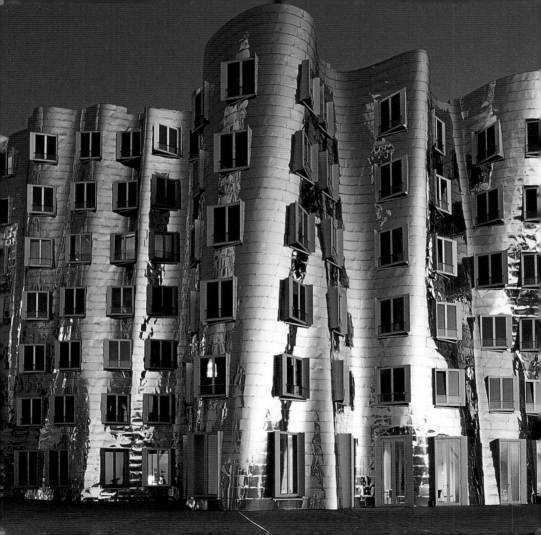

## *Qu'est-ce que c'est?*

It's a bird! It's a plane! It's Superbuilder! Super-*who?*

Have you ever stood before a building and thought, "*Huh?* What was the architect thinking?" Meet **Frank Owen Gehry** (b. 1929), über-designer of nervy, curvy buildings that have delighted and puzzled people for decades. His works have raised more eyebrows than those of any other architect in our time, and for good reason: We've never seen anything like them. Gehry's swoopy, free-form structures have sprung up in a world dominated by humdrum, predictable, boxlike architecture. Yet for many people, the question remains: *Who is he?*

## A friendly giant

At first glance, Gehry's encounter with architecture looks like a journey without a map. By seeking more from his buildings than status, profit, and feel-good security, Gehry invites dialogue about the times we live in. His works often *ask* more questions than they answer. He seduces the imagination and transcends nationality, geographical boundaries, and aesthetic status quo. And the result is that his buildings catch us off guard.

OPPOSITE
Der Neue
Zollhoff
(The New
Customs House)
Düsseldorf
Germany

Gehry's face appears in American Express ads and in Apple Computer's *Think Different* campaign. He has won more than 100 awards for his work, including the prestigious Pritzker Prize, architecture's equivalent of the Nobel Prize for lifetime achievement. The Gehry-designed Guggenheim Museum in Bilbao, Spain, which opened in 1997, instantly became one of the great architectural landmarks of the 20th century, ranking right up there with Frank Lloyd Wright's **Solomon R. Guggenheim Museum** (1959) in New York City, with Le Corbusier's **Chapel of Notre-Dame-du-Haut** (1950–55) at **Ronchamp**, France (see pages 20–21), and with Danish architect Jorn Utzon's **Sydney Opera House** (1957–73) in Australia.

BELOW LEFT
Sydney Opera
House
Australia

BELOW RIGHT
Solomon R.
Guggenheim
Museum
New York, NY

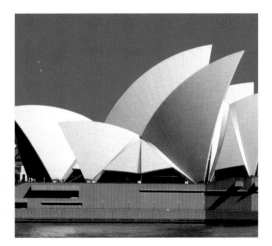

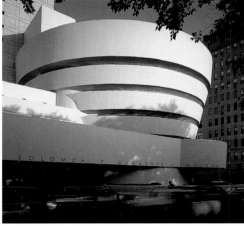

## *What gives?*

Maybe Gehry's architecture baffles you. When you read this book, however, you'll see how simple it is. And therein lie his genius and mystery: Gehry's buildings are an expression of the human spirit wrestling within its *skin* and reacting to the world around it. To understand Gehry's work, consider the three main stages of his career:

- **Finding his voice (1957–1963):** Early architectural commissions, including small buildings, offices, etc.

- **Pushing the envelope (1964–1987):** Experimentation with the *village of forms* design concept in which a structure is broken down into its component parts, each of which contributes to the overall design. This phase includes private residences (in particular, his own house in Santa Monica, California); the growing use of industrial materials (chain-link fencing, concrete blocks, etc.); and, as a diversion, the design of furniture made of cardboard and bent wood.

- **Hitting his stride (1988–present):** Linear, geometric structures give way to swoopy-walled, titanium-clad abstractions, such as the Guggenheim Museum in Bilbao, Spain, and the Experience Music Project in Seattle, Washington. For many people, the term *Gehry style* is synonymous with this distinctively curvy look.

## On the prowl

What elevates Gehry into a class of his own is his *relentless quest for new forms*. As a rule, most architects are content to meet their clients' needs (e.g., the pool must be located in the morning sun, the bedroom must be *so* big, etc.). They package their solutions in conventional styles (e.g., colonial, ranch, etc.) derived from architectural history and updated to suit a client's whims. While the Santa Monica, California–based Gehry knows architectural history and can speak it fluently when necessary, he has not sought inspiration in the architectural past. Instead, he has been influenced by the world of art—and, in particular, by American Pop artists and Minimalist artists of the 1950s and 1960s, such as **Jasper Johns** (b. 1930) and **Robert Rauschenberg** (b. 1925), and sculptors **Carl Andre** (b. 1935) and **Donald Judd** (1928–1994), who radicalized art by taking everyday objects and materials—library books, a stuffed goat, stainless steel—and creating provocative works that question the idea of what constitutes *art*. Gehry was drawn to their way of approaching art as an ongoing experiment that discovers new forms and images and arouses complex emotions.

## Doing it his way

Gehry approached architecture the same way. One way or another, he has engaged in that quest since first opening his own office in 1962 in the beach town of Santa Monica, California. No other 20<sup>th</sup>-century architect, except perhaps **Frank Lloyd Wright** (1867–1959), succeeded in creating a body of work that contained so many styles, innovative uses of forms and materials, and the unabashed power to wow the public in each successive project. But unlike Wright or the other acknowledged architectural stars of the Modern era—**Le Corbusier** (1887–1965), **Ludwig Mies van der Rohe** (1886–1969), and **Walter Gropius** (1883–1969)—Gehry preaches no specific theories of design or style. He has not written books or papers, nor has he set up a West Coast equivalent of the Bauhaus or Taliesin. He disassociates himself from any stylistic school—Modernist, post-Modernist, constructivist, deconstructivist—and is dismayed when people talk about his *disciples*. He has never claimed any; he is not a guru. So who (and what) is he?

BELOW LEFT Frank Lloyd Wright

CENTER Mies van der Rohe

RIGHT Le Corbusier and Walter Gropius

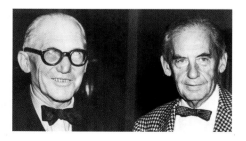

## North of the border

*And so the story begins:* Gehry's father, **Irwin Goldberg**, grew up in the tough streets of New York City and drifted north to Toronto, Canada, looking for work. There, he met and married **Thelma Caplan**, a music graduate from the Hamburg Institute, a conservatory in Toronto, who participated in local Yiddish theater. On February 28, 1929, she gave birth to Frank Owen Goldberg, who would later change his surname to Gehry to avoid anti-Semitism.

### *Carpe Fishem*

Thelma was instrumental in exposing her children—Frank and his younger sister, **Doreen**—to the arts. She took them to visit the city's art museum and to the local

Frank O. Gehry
at age 4

philharmonic. Gehry's maternal grandmother Caplan also exerted a strong influence on the boy. Every Thursday, she would buy a live carp at the market to make gefilte fish; she would take the carp home in a paper container filled with water and put it in the bathtub overnight. Young Frank would watch the creature swim in the tub, enamored of its seamless blend of form, function, beauty, and hypnotic movement.

## A restless father

Gehry's father tried his hand at a number of small businesses, and for a while moved his family to the backwater gold-mining town of Timmins, in northern Ontario, where he succeeded briefly in selling slot machines and pinball machines to local bars, restaurants, and carnivals. It was a bleak existence for young Frank: He was the only Jewish boy at the Timmins grade school and found himself the target of regular beatings by his anti-Semitic classmates.

Years later, Gehry would fondly recall the adventure of going on sales calls with his father to saloons, but he would also remember the fric-

Sound Byte:
*"Every architect who's any good, no matter what they say, is trying to make some kind of personal mud pie."*
—FRANK O. GEHRY, 1989

tion that existed between father and son. Irwin had grown up a tough street fighter and had gone on to box semiprofessionally. He had a vicious temper that he often focused on Frank, whom he considered to be something of a dreamer, a boy who really didn't know the value of a dollar.

When the Canadian government outlawed slot machines, Irwin moved his family back to Toronto and ploughed his savings into a small furniture business, only to have it fail—an event that left him broken in spirit and health. Frank and his mother had the humiliating task of auctioning off his father's assets.

## Busy boy

OPPOSITE
Experience
Music Project
Seattle
Washington

From the age of 10 to 17, after his family's move back to Toronto, Gehry worked as a part-time stock boy in his grandfather's downtown hardware store and developed a passion for taking apart and reassembling broken toasters and clocks in the store's backroom repair shop. His grandmother took home scraps and shavings from her husband's hardware store and entertained young Frank for hours with them, building imaginary houses and futuristic cities on the living-room floor. It was a formative experience—taking cast-off materials and using them to make things of beauty and wonder—and Gehry remembered it years later when fish emerged as a recurring image in his art and career. Fish seemed to him a symbol of unattainable perfection—

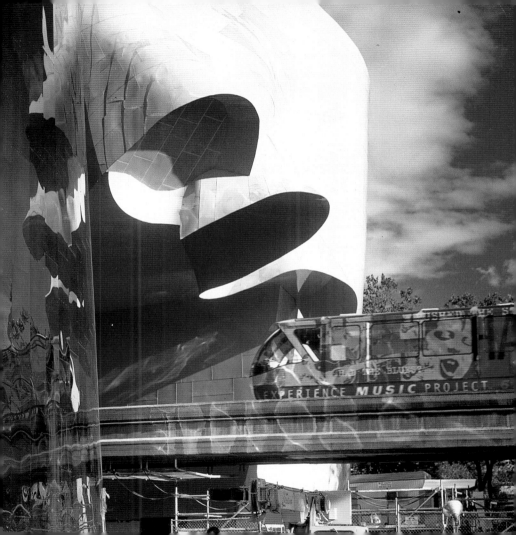

the ultimate goal in his creative pursuits. Fish would become at once his symbol, his mantra, his talisman, and an ongoing joke in his work—and the inspiration for some of his most provocative buildings.

## Surf & turf

In 1947, searching for a brighter future, the family packed their bags and moved to Los Angeles, land of the American Dream for thousands of transplants from all over. Los Angeles was then in the forefront of what would become a nationwide postwar boom, fueled by expanding middle-class wealth, military spending, the spread of car culture, and the sprawl of suburbia.

Sound Byte:

*"When I came to Los Angeles in the 50s, it was kind of a frontier. People were attracted to this place because it was an area of opportunity. It was the place where the postwar fast-food culture reached its highest expression. After going through the war, people wanted everything fast. Los Angeles was kind of a white canvas. It was blank."*

—FRANK O. GEHRY, 1995

But Gehry and his family saw little of this growing prosperity when they arrived in 1947. The family was so poor that they could afford

only a small two-room apartment downtown at $9^{th}$ and Burlington, in a less-than-prosperous area. Since everyone had to work, the 18-year-old Gehry got a job with a company that manufactured breakfast nooks (i.e., a prefab combo of table and bench that was installed in a space usually adjoining the kitchen). For seven years, he delivered the nooks by truck and installed them in kitchens all around the Los Angeles area. During this time, he made friends with the husband-and-wife singing-cowboy movie stars **Roy Rogers** (1911–1998) and **Dale Evans** (1912–2001), who later introduced him to comedian **Bob Hope** (b. 1903). It was also on this job that Gehry met the woman who would become his first wife—**Anita Snyder**. They were married in 1952 and she found work as a legal secretary to help put Frank through school. The marriage would produce two daughters.

## From nooks to books

Gehry escaped the gloom of his breakfast-nook work by taking night classes in fine arts at the University of Southern California, where he found an important mentor and friend in **Glenn Lukens**, a noted local artist, who taught Gehry's ceramics class. As luck would have it, Lukens was having a house built by legendary California architect **Raphael Soriano**, famous for designing beautiful Modernist homes— and for his eccentric clothing and behavior. Lukens took Gehry to observe Soriano in action on a site, and Gehry fell in love with the sce-

nario he witnessed: Here was a short little man with a broken nose, dressed in black, wearing a beret, shouting at contractors while railing against the designs of Frank Lloyd Wright. Hooked on the excitement, Gehry switched majors and enrolled in the School of Architecture—then something of a bastion of California Modernism.

At USC, Gehry fell under the sway of the reigning Modernist style, and on Sundays he would drive around Los Angeles with his friends, looking at the Case Study Houses discussed in their courses (see opposite page). His senior thesis, inspired by the frenzy of the Modernist Zeitgeist, was a plan for affordable housing.

*The New Yorker*
September 18, 2000

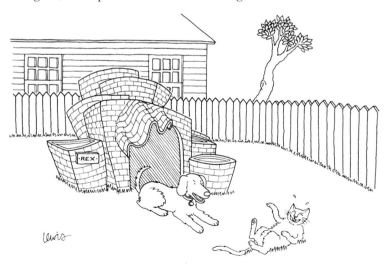

*"I guess cats just can't appreciate Frank Gehry."*

## CALIFORNIA MODERNISM

By the late 1940s, Southern California had become the breeding ground for Modernism, which sought to reshape the prevailing style of Spanish-style haciendas, American colonials, and bungalows.

The seeds of Modernism were planted in the 1920s when architects such as **Richard Neutra** (1892–1970) and **R[udolph] M. Schindler** (1887–1953) fled Europe and settled in Southern California. They brought with them the International Style, with its box-shaped structures of simple design, made of glass and concrete, with free-flowing interiors, stripped of decoration.

After the war, **John Entenza** (1906–1984), editor of *Arts + Architecture* magazine, picked up the Modernist gauntlet and launched a plan to sell the International Style to growing middle-class America as a comfortable, cost-effective design that was easy to build, easier to live in, and—most important—fashionable.

To demonstrate those ideas, Entenza and *Arts + Architecture* sponsored the **Case Study Houses** program—the design and construction of some 36 homes that would dot the hills and canyons around Los Angeles. They were designed by the leading architects of the day—including Neutra and **Charles Eames** (1907–1978)—and were intended to showcase a contemporary style that could be replicated across the country. The widespread Modernist boom that Entenza had hoped for never materialized, but the contemporary style did influence suburban housing for the next 20 years.

Richard Neutra
Lovell House
Los Angeles, California
1927–29

Charles Eames
Eames Residence
Santa Monica, California
1949

## Goldberg begets Gehry

Gehry learned his lessons well and graduated at the top of his class with a Bachelor of Architecture degree in 1954. He and Anita were expecting their first child, **Leslie.** (A second daughter, **Brina**, would follow two years later.) Anita did not like her husband's surname—Goldberg—and suggested he change it, in part because of the anti-Semitism he had suffered as a child and as an undergraduate at USC. After receiving his family's good blessings for the change, Frank Owen Goldberg officially became Frank Owen *Gehry*, a name dreamed up by Anita.

The young architect wanted a career that involved more than "designing windows for rich people," as he described it. Fortunately, he was exposed to some progressive professors at USC, such as **Gregory Ain** (1908–1988), who had apprenticed with Modernist master Richard Neutra and who was deeply interested in affordable housing. They pointed Gehry toward city planning, since it would allow him to use architecture to effect social change.

## Half-hearted at Harvard

In the fall of 1956, after a two-year stint in the U.S. Army, Gehry moved his family to Cambridge, Massachusetts, where he enrolled in Harvard University's Graduate School of Design—at that time, the international center for social change through better city planning.

## A new direction

No sooner was Gehry on campus than he discovered that urban planning at Harvard was more theoretical than hands-on. What's more, Gehry's left-wing ideas about socially responsible architecture were at odds with the clubby atmosphere at Harvard. The final straw came when he sat in on a discussion of one professor's "secret project in progress"—a palace that he was designing for right-wing Cuban dictator **Fulgencio Batista** (1901–1973), whom **Fidel Castro** (b. 1927) would later overthrow. The disheartened Gehry was underwhelmed by this "social project," so he left the school of architecture and began auditing classes in other departments on campus. He had received little exposure to European architectural history at USC, but that quickly changed when he attended lectures by experts like Siegfried Giedion and Eduard Sekler. They introduced Gehry to the work of the architect whose style would have a monumental influence on the transplanted Canadian's career: Le Corbusier.

**Sound Byte:**
*"Gehry's buildings are powerful essays in geometric form and materials, and from an aesthetic standpoint they are among the most profound and brilliant works of architecture of our time."*
—PAUL GOLDBERGER, *The New York Times*, 1989

Le Corbusier

Charles-Édouard Jeanneret (1887–1965), who would later change his name to Le Corbusier, was born in 1887 in La Chaux-de-Fonds, Switzerland. He went to an art school to become a watch engraver, but had a talent for structural design and decided to become an architect. Jeanneret left Switzerland for France and, after World War I, devoted his energies to building up the war-ravaged France. He developed a new construction method that he called *le plan libre* (open plan) and soon attracted a cult following by churning out lectures, mission statements, books, paintings—and buildings, which included such postwar landmarks as Unité d'Habitation in Marseilles, France (1952), a housing block that would serve as the model for inner-city projects across America. By the mid-1950s, Le Corbusier became something of a puzzle when he shed his sleek-box Modernism for a more intuitive, free-flowing Expressionism, done in dense, raw concrete. His pilgrimage chapel, Notre-Dame-du-Haut (Our Lady on High), built at Ronchamp, France, in 1954, rocked the world (see opposite page). Rough masonry walls faced with whitewashed Gunite (i.e., sprayed concrete) reinforce the small concrete structure. Its dramatic roof resembles an oversized nun's habit or a pair of hands clasped in prayer. Dozens of colored-glass windows give the impression of having been haphazardly chiseled by primitive artisans into the chapel's massive concrete walls. The effect is one of haunting mysticism. Le Corbusier died on August 27, 1965, of a heart attack while swimming near his home in the South of France. He was 77.

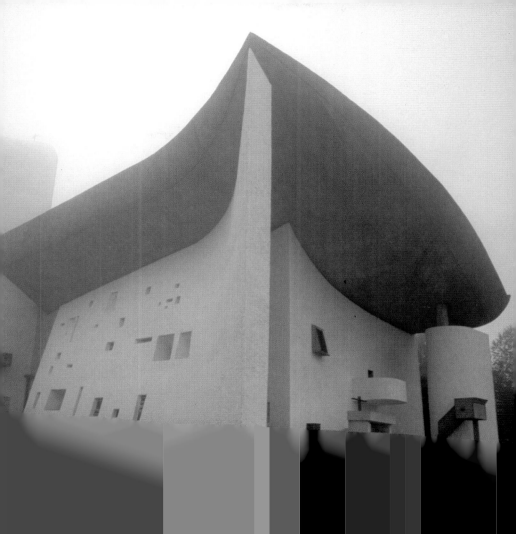

Le Corbusier's chapel in Ronchamp, France, fascinated Gehry. It thrilled him to learn that Le Corbusier, unlike most architects, had derived his designs from his *own* art, not from the work of others. Le Corbusier had been a Cubist painter earlier in his career and would later draw upon these paintings when designing buildings. This helped Gehry see that it was possible to break through the bonds of architectural history and venture into other realms, such as painting and sculpture, in his search for sources.

## Becoming a suit (not)

OPPOSITE
Schnabel House
Brentwood
California
1986–89

After returning to Los Angeles in the spring of 1957, Gehry took a job with the large architectural firm of **Pereira and Luckman**. A year later, he moved to another firm, **Victor Gruen Associates,** where he had apprenticed part-time during his student years at USC. Gruen was a leader in the development of a new kind of structure at that time: the shopping mall! Gehry spent nearly four years with Gruen and developed a facility for designing malls that would later come in handy in his future projects. But he also designed his first residence—the **Steeves House** (1958–59), a single-family, three-bedroom home in Brentwood, California—that was less a personal statement than an exercise in applying the contemporary-modern plan, with a good dose of Frank Lloyd Wright.

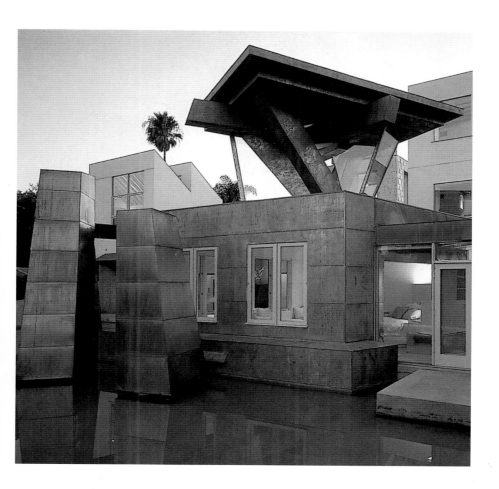

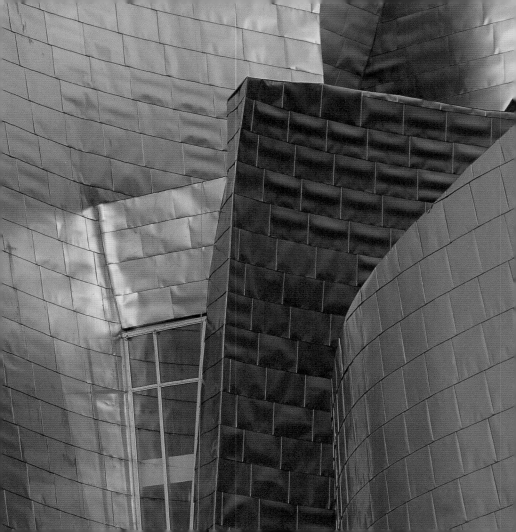

## Finally, FOGA

For the most part, Gehry's contact with the big commercial architectural firms left him cold, so in 1961 he took a job in the Paris architectural firm of **André Remondet**, moved his family to France, and spent weekends studying great buildings such as Le Corbusier's chapel at Ronchamp.

A year later, he returned to Los Angeles and opened his own firm, **Frank O. Gehry and Associates, Inc.**—aka **FOGA**—in Santa Monica. He got started with a client who paid him $2,000 to design a small warehouse and company headquarters. Word of mouth brought him new clients during the 1960s and 1970s as Gehry built up his practice by designing small shops and offices, apartment buildings, recreation centers, townhouse complexes, parks, and municipal buildings—with an occasional museum installation or private residence thrown in for variety.

Gehry earned a local reputation as a solid commercial architect who brought in projects on time and within budget. Whenever possible, he sought to add imaginative flair to these commercial projects, as in the **Kay Jewelers** office and warehouse in Los Angeles that he designed in 1962. These clients were big fans of Japanese art, so Gehry created a project that evoked the spirit of a Shinto temple by using principles, forms, and details from traditional Japanese architecture. The building

OPPOSITE
Detail of
Exterior Walls
Guggenheim
Museum
Bilbao

was set back from the street by a walled-in garden, complete with small pool, rocks, and bamboo thickets. To cut costs, Gehry realized his Japanese themes by using *cheap American building materials*. He created the low wall surrounding the garden with exposed concrete blocks traditionally used for foundations and covered in stucco or bricks.

Eventually, his firm landed steady work from the Rouse Company, the nation's largest developer of shopping malls. The firm would account for nearly 20 percent of Gehry's business from 1965 to 1976. But for the most part, the 1960s were a stressful time as Gehry struggled to find his architectural voice while also building a strong base of diverse commercial clients.

The quest for this voice led the young architect into the small but intense Los Angeles art scene that was sprouting up in the rundown warehouses of Santa Monica and Venice. As early as 1961, Gehry began visiting art galleries along La Cienega Boulevard between Melrose and Santa Monica. Soon, he made friends with controversial artists such as **Ed Kienholz** (1927–1994), **Billy Al Bengston** (b. 1934), **Ken Price** (b. 1935), **Robert Irwin** (b. 1928), **Ed Ruscha** (b. 1937), and **Larry Bell** (b. 1939), who were rebelling against the prevailing notions of art and exploring different approaches to the use of light, space, and materials. Kienholz, for example, hunted in the junkyards of Los Angeles for broken clocks, rusty old bed frames, damaged mannequins—and combined them in bizarre narrative sculptures that provided a haunting counterpoint to the sun & surf culture all around him.

**Sound Byte:**
*"Paintings are a way of training the eye. You see how people compose a canvas. The way Brueghel composes a canvas versus the way Caravaggio composes a canvas or Jasper Johns. I learned about composition from their canvases."*

—FRANK O. GEHRY, 1993

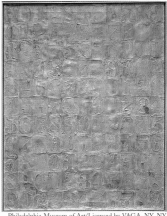

ABOVE
Jasper Johns. *Sculptmetal Numbers*
1975
Sculptmetal on canvas
59 x 45" (151.13 x 114.3 cm)

RIGHT
Robert Rauschenberg. *Monogram*
1955–59. Combine: oil, paper
fabric, metal, wood, rubber shoe
heel, tennis ball on canvas
with oil on Angorra goat and
rubber tire, on wood platform
mounted on four casters
48 x 72 x 72"
(122 x 183 x 183 cm)

POP ART AND MINIMALISM

The roots of American **Pop Art** can be found in the early works of **Robert Rauschenberg** and **Jasper Johns**, who initiated a series of revolutionary works in the 1950s by incorporating found objects and everyday cultural icons into their art.

Rauschenberg scoured the streets of New York City looking for cast-off materials ranging from old quilts to rusting bed springs and stuffed goats, and incorporated the material into his paintings, to give rise to what he called *combines* (e.g., *Monogram*, 1959), which were part painting, part sculpture.

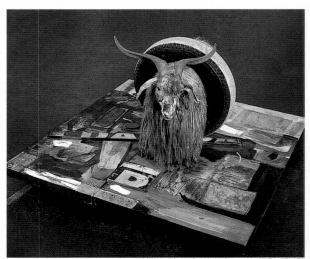

Johns, a close friend of Rauschenberg at the time, took another approach, and began constructing works using American flags, numbers, and alphabet letters.

Both artists used the incorporated objects to provoke the viewer by raising a host of questions about the nature of the work and the culture that gave rise to them: Is it painting or sculpture? What is the role of objects? Is that goat a joke? What does a surface of sculpted-metal squares with numbers on them represent?

As such, these works opened up a new realm of source materials and ideas for art. In turn, this fueled the explosion of Pop Art in the 1960s with the careers of such artists as **Andy Warhol**, **James Rosenquist** (b. 1933), and **Claes Oldenburg** (b. 1929). Another approach that developed in the 1950s and early 1960s was **Minimalism**. It sought to remove all imagery and narrative content from a work, and focus instead on the basics of line, color, and shape. This attitude found expression in the sculpture of Donald Judd and Carl Andre, who used everyday industrial materials, from railroad ties to sheet metal, to construct simple, geometric forms that exuded tremendous power, as in works such as Judd's *Untitled* (1966).

By stripping away all traditional references, Judd and Andre forced the viewer to look more closely at the work, evaluate its shape and forms, and determine its relationship to its environment—and even to traditional figurative sculpture.

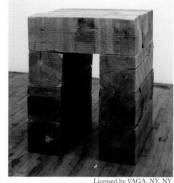

Carl Andre. *Cedar Piece*
1960–64
Wood.

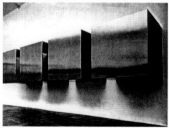

Donald Judd. *Untitled*
1965
Stainless steel and plexiglass
34 x 160 x 34"
(86.5 x 406.5 x 86.5 cm)

## A pilot light goes on

Thanks to his artist friends in Los Angeles, Gehry was introduced to luminaries of the New York art scene such as Robert Rauschenberg, Jasper Johns, Andy Warhol, and others at the heart of Pop Art. Under their influence, he discovered a new way of looking at the world and his work by making art out of objects such as old tires, broken signs, stuffed chickens, and zinc. The materials didn't matter. How you used them *did*.

**Sound Byte:**

*"If Jasper Johns and Donald Judd can make beauty with junk materials, then why can't that transfer into architecture?"*

—FRANK O. GEHRY

Everyday objects that had been thrown out, ignored, or rendered invisible by mainstream culture came to represent what a society valued as much as what it was trying to hide. Though Gehry couldn't use stuffed goats or old tires in his buildings, he was free to improvise with materials he could use—such as corrugated metal, plywood, and chain-link fencing. He did it for the same reasons his artist friends did: *He wanted to raise questions about the culture and the times*. Gehry's friends provided him with contacts that led to new clients, and this enabled

him to develop an experimental sideline practice in addition to his nine-to-five commercial work.

## Toying with the box

In 1964, graphic designer **Lou Danziger** hired Gehry to design a structure that would be part studio (1,000 square feet) and part townhouse (1,600 square feet) at the busy intersection of Sycamore and Melrose Avenues in Hollywood. Gehry devised a small complex of two separate concrete boxlike buildings connected by a high, walled-in garden that read like a third box from the street. The blue-gray stucco was left exposed on the outside walls so that the walls could build up a coat of grime that blended into the surrounding neighborhood of gas stations and tire shops.

The **Danziger Studio and Residence** was a breakthrough project for Gehry. He brought it in on time and under budget, and used his design to create what appeared to be a giant Minimalist sculpture of three large volumes that played off one another.

Danziger
Studio/Residence
Hollywood
California
1964
View of the
exterior with
garden wall in
foreground

**Sound Byte:**
*"As soon as I understand the scale of the building and the relationship to the site and the relationship to the client, as it becomes more and more clear to me, I start doing sketches."*

—FRANK O. GEHRY

## Scribble, scribble

In 1966, Gehry became more "hands-on" himself. Instead of using pencil and T-squares to work out his projects on the drafting board, as did most architects of the pre-computer era, he broke down the project

into minute details, then scribbled a few sketches and began to build models. He *sculpted* his designs out of cardboard, paper, wood, and anything else he could find. How was this new? Well, in the 1960s, this thinking was fine for a painter but unthinkable for an architect. *Concrete blocks were meant for foundation work, not as thought-provoking decorations.* Architecture was a business. Business was about predictability. And that meant using the tried-and-true tools of the trade—pencils, T-squares, and drafting boards—to design structures made of steel, glass, and concrete. Surprises were unwelcome.

## Minimalism on Melrose

Gehry's contacts with the Los Angeles art scene ignited his desire to experiment. But finding a way to do so was not easy. His commercial work depended on bringing in projects on time and within budget, with no frills or quirky touches that would increase costs. However, he realized that his bliss lay with the artists and that he could not give up trying new ideas, testing materials and limits, and developing a voice of his own.

To solve the dilemma, Gehry developed a two-track practice: The one was devoted to the nine-to-five, routine developer kind of work; the other focused on experimental projects that gave him wide latitude to do whatever excited him. This experimental side helped him become known as a quirky architect who wasn't afraid to take creative risks.

Case in point: In 1968, Gehry designed an exhibit space for the works of his close friend Billy Al Bengston at the Los Angeles County Museum of Art (LACMA). As Gehry saw it, Bengston's art rose from the rough-and-tumble world of his motorcycle racing, so the challenge was to capture that brash, exuberant energy in the conservative institutional setting of LACMA.

Though he appeared conventional on the outside, dressed in his khakis and open-collar Oxford shirts, Gehry was more radical on the inside. He divided the exhibit into a series of rooms and booths made of exposed-wood studs, raw plywood, and corrugated metal—the first use of what would soon become signature materials in his work. The museum officials were not thrilled, but the exhibit remained, since Bengston loved it. In a subtle way, Gehry's design subverted the very authority of the museum that was sponsoring it. His rough-and-tumble exhibit seemed to proclaim: *Don't look to museums to tell you what art is. Look to the artists who create it.*

## On the home front

Gehry's marriage with Anita Snyder broke up over what he called "a clash of egos." But in 1968, destiny smiled on him when the striking young Panamanian-born **Berta Isabel Aguilera** (b. 1943) arrived one day at Gehry's office to interview for a job. As it turned out, the position involved a lot of phone work and Berta feared her Spanish accent

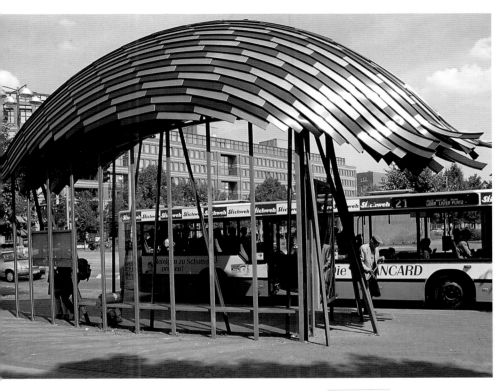

Fish-shaped Bus Stop
Hannover, Germany

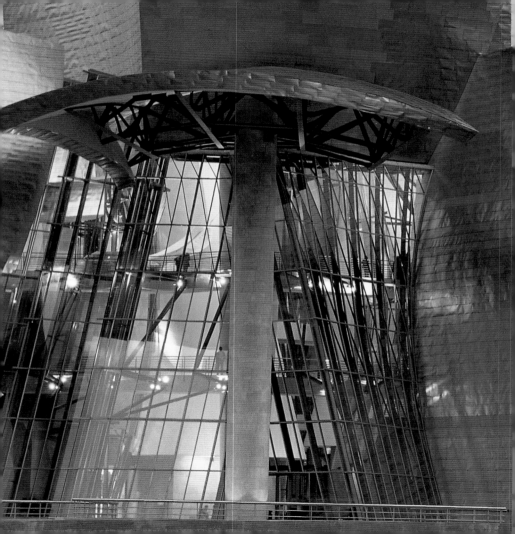

might be a hindrance, so she passed on the job. But a month later, Gehry asked her out to dinner, she accepted, and thus began his life-long romance with a woman 14 years his junior. She would ultimately become a financial backbone of his company.

OPPOSITE
Guggenheim
Museum
Bilbao

## A playful digression

Curiously, Gehry first gained national attention not with a building—but with a chair! Like most architects, Gehry built inexpensive site elevations for his project models by gluing together sheets of ordinary cardboard to depict ground contours. One day in 1968, while looking at one of these models, he noticed the cardboard contours and wondered if the material could be used for something else—such as low-cost furniture.

To find out, Gehry began testing cardboard to determine its strength, workability, and durability, just as a sculptor might consider new materials to work with. He eventually discovered that cardboard sheets glued together in stacks become incredibly strong and can easily be cut into virtually any shape with a jigsaw. Encouraged, he designed some furniture pieces. His first was a long conference desk, laminated with white plastic for added strength. Before long, he had created the *Easy Edges* line of cardboard furniture, consisting of 17 pieces that included rocking chairs and end tables. Retail prices ranged from $15 to $115. The collection was released in the spring of 1973 and attracted huge

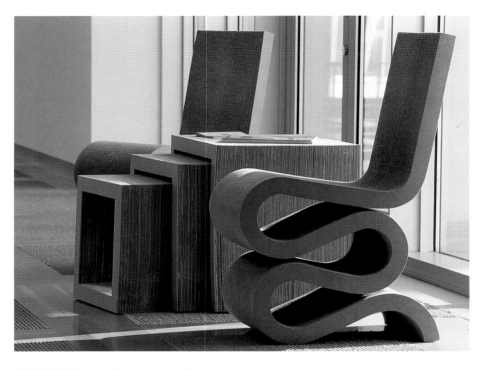

Cardboard furniture from Gehry's *Easy Edges* line

media coverage. The press touted his line as the "Volkswagen" of furniture: stylish, functional, and inexpensive. But within three months, Gehry pulled the plug on the venture, since it was robbing too much time from his practice. After all, he was an architect, not a furniture maker. Nonetheless, the episode demonstrated Gehry's ability to transform everyday materials into something unexpected.

## The missing link

In 1975, Gehry and Berta were married and would eventually produce two sons: **Alejandro** (Alex) and, four years later, **Samuel** (Sammy). The architect became obsessed with the idea of working with idiosyncratic materials and unorthodox structures, especially **chain-link fencing,** the ultimate symbol of *access denied*. Chain-link fencing has been used to rope off everything from backyards to military missile bases, but was so ordinary that no one took note of it—until Gehry started using it in unexpected ways. His discovery that chain-link fencing cast thrilling visual effects with its ghostly shadows prompted Gehry to use it in 1976 in his designs for beach pavilions at Shoreline Aquatic Park in Long Beach, where he created a chain-link trapezoid to enclose a small park of trees, grassy hills, and a winding path. The result was at once compelling and baffling.

## "Village of forms"

The same year, Gehry toyed with the idea of breaking down a project into its component parts, giving each part a distinct identity and then arranging these parts into a *village of forms*. The idea was to create a building that could be experienced simultaneously as individual elements and as part of a whole. He explored this concept while sketching the design for the Jung Institute in downtown Los Angeles. The institute wanted a building that would blend into its industrial neigh-

borhood, but that would have space for a variety of functions. Gehry's design featured a cratelike, boxy building that screened out the surrounding rough neighborhood and that held a series of sliced geometric shapes emerging from the roof. Each shape designated a different use of office space and functioned as a skylight. The institute later abandoned the building, but his concept would prove valuable for future projects.

## And the beat goes on

Although Gehry continued to prosper as a nine-to-five commercial architect, he felt as though he were leading a double life: The bulk of his work continued to be corporate—and not experimental—and he wanted that to change.

He had become intrigued with the unfinished houses sprouting up in suburban Los Angeles. Their raw, balloon-frame structures interested him more than the Tudor, Colonial, or ranch-style fronts that would eventually be tacked over them. The raw, builderlike framing conveyed a sense of immediacy and texture, like the preparatory brushstrokes underlying a completed painting. Gehry wondered how one might capture that raw energy in, say, a finished house. The answer lay just around the proverbial corner.

## Gunshots in Santa Monica

In 1977, after the birth of Alejandro, Berta decided that the family apartment in Ocean Park was getting cramped. They lacked the money to build a dream house, so Berta began shopping for a residence they could afford. She found a nondescript 1920s Dutch Colonial, with salmon-pink asbestos shingles and green trim, on the corner of a tree-lined street in Santa Monica, several miles from the beach. Gehry described the place as a "dumb little house with charm"—and they bought it.

Sensitive to her husband's growing frustrations at work, Berta encouraged him to use their residence as a kind of experimental workshop for his designs. The idea excited him—and the result has become known as the **Gehry Residence**.

Gehry began the project by opening up the tight 1920s floorplan. He wrapped an 800-foot-long, L-shaped addition made out of mundane corrugated metal, raw framing, and plywood two-by-fours around the existing house, thus remaking the Southern California tradition of indoor-outdoor living. Chain-link fencing decorated the second story like a little-league backstop gone haywire. By wrapping the perimeter of the lot with construction materials and leaving the original house as it was (including the asphalt driveway, which became the floor of the new kitchen), Gehry created a new space between the property lines

and the old house. When he added a roof over this space, it became an "addition" to the old house and created a new, confusing space: The dining room and kitchen now occupied former outdoor space, including the original windows and pink siding. For critic Paul Heyer, "Gehry lifted back the skin to reveal the building as layers, with new forms breaking out and tilting away from the original. It was almost an idea of *wrapping* à la Christo." While sitting inside the *new* house, one was also outside the *old* house.

The kitchen was flooded with natural light from the tilted-glass cube that, when viewed from the inside, provided a breathtaking frame for the towering trees outside and created the feeling of being inside a splendid cathedral, alive with mystery and magic. This sense of wonder continued as you moved through the first floor. Gehry had

Gehry
Residence
exterior
Santa Monica
California

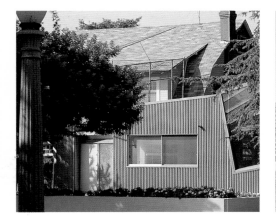
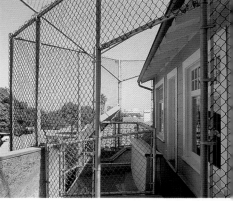

refinished some walls with plasterboard and stripped down others to expose the framing, beams, wood lathe, and joists. Here and there, he had retained whole chunks of the previous house—such as the traditional molding around the set of windows overlooking the new kitchen.

On the second floor, Gehry knocked out the ceiling of the master bedroom in order to open up the room into what had been the attic. This introduced a vault of exposed framing and thus created the feel of a spacious tree house, indirectly lit by large square clerestory windows cut into both sides of the house.

The Gehry Residence is an experience that alternately surprises, delights, and alarms viewers. Gehry had transformed the small, undistinguished bungalow into a controversial work of art that gave the appearance of being unfinished. Many of his middle-class neighbors

Gehry
Residence
kitchen
Santa Monica
California

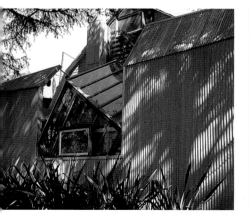

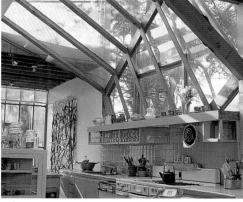

Gehry Residence
original structure
(left) and
after renovation
(right)
1977–78
Santa Monica
California

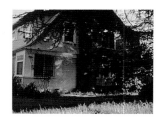 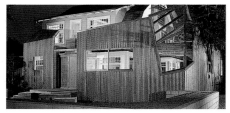

threatened to sue, and for a time, one disgruntled neighbor regularly brought his dog by to relieve himself on Gehry's property. On two occasions, a shot was fired through Gehry's windows.

## The world takes note

Meanwhile, a steady stream of influential visitors beat a path to Gehry's door, ranging from the doyen of American architects, **Philip Johnson** (b. 1906), to artists such as the American Minimalist sculptor **Richard Serra** (b. 1939) and Swedish-American Pop sculptor Claes Oldenburg. They came, they saw, and they were conquered. Soon the house was written up in magazines of every kind. Even *People* magazine got in on the act.

Gehry was suddenly an international star. He had boldly proclaimed his vision of architecture as sculpture endowed with freedom from restraint. The critical consensus was that the house was unusual and difficult to understand, but nonetheless a landmark that, in its own

way, was as significant as Thomas Jefferson's Monticello (near Charlottesville, Virginia), Frank Lloyd Wright's Fallingwater (in Ohiopyle, Pennsylvania), or Philip Johnson's Glass House (in New Canaan, Connecticut). The American Institute of Architects selected Gehry's house for its prestigious honor award, noting that it was "an expansion of the American Dream into new areas."

Love it or loathe it, the house was a turning point in Gehry's career and provoked passionate discussion. Gehry had built a revolutionary structure that challenged the prevailing idea of what a house should be. In fact, his new house made sense only if you thought of it not as a house, but as a sculptural object, a work of Pop Art. At night, the old pink house looked like a precious family jewel, dramatically arrayed in an elegantly wrought post-Modern box of corrugated metal, chain link, and plywood.

The experiment helped Gehry break new ground in developing his own architectural language. He created an exterior that lured you inside, and once he had you there, fashioned an unraveling series of visual surprises that led you to *see* differently: Old windows framed new kitchens; new windows framed sky and trees; new bedrooms looked into old attics that had become redwood vaulted ceilings; and new walls of plaster looked at old walls pared down to lathe strips. It looked like a Hollywood back lot—the ultimate in illusion—and demonstrated that Gehry had broken the box for good.

**Sound Byte:**

*"What is architecture? It's a three-dimensional object, right?
So why can't it be anything?"*

—FRANK O. GEHRY, 1997

## Radical changes for a radical

The international success of his Santa Monica residence brought Gehry to the attention of potential clients who were intrigued with his provocative style. This buzz produced an unintended result that would change his life even further. At the same time that Gehry was finishing work on his residence, he was also completing work on a $50-million mall in downtown Santa Monica for the Rouse Company, his largest commercial client. One night, Gehry invited the company's president over for dinner, and the man—stunned by the architect's newly renovated house—told Gehry that if this house was the kind of architecture he wanted to design, then he should follow his heart and get out of the mall business. Gehry pondered his comments for two days and realized the man was right. He amicably withdrew from the mall commissions and slowly scaled back on other corporate projects accepted by his firm. Over the next three months, he reduced his office staff from 40 to three and effectively ended the architectural "double life" he had been leading since the 1960s. He was 50. He was starting over. From now on, he would design only buildings that delighted him.

## Gaining steam

As a result, for the third time in his life Gehry was faced with building up a client base. But his experimental work of the 1960s and early 1970s gave him a head start. He now had a track record and a name. Clients who wanted something different began coming to Frank O. Gehry. In 1978, only months after making this pivotal career move, Gehry was hired to design the **Familian House** in Santa Monica. He broke the project into two buildings: a 40 x 40-foot cube that contained the living and entertaining areas; and a 20 x 110-foot structure that housed the family bedrooms. Both structures were sheathed in stucco, then connected by a series of bridges. They featured raw framing encased in glass and accented by plywood decks, and windows and skylights with exposed studs. The result caused onlookers to wonder if the house was still under construction or being torn down.

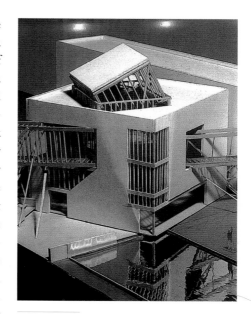

Familian House
(architect's model; unbuilt)
Los Angeles, California

47

## Chain link...and ivy

In 1979, Gehry revisited his cardboard furniture line, introducing a playful variation of the *Easy Edges* concept called *Experimental Edges*. Whereas *Easy Edges* had been strong and linear, *Experimental Edges* offered a jagged, shaggy profile. Both lines were glued and laminated. For financial and production reasons, Gehry moved away from furniture in 1982.

The year 1979 also saw Gehry enter into a long-term association with Yale University when he became the William Bishop Professor of Architecture. The considerable talents of this no-rules maverick had now been sanctioned by the Ivy League.

## L. A. Style

By 1980, Gehry's idea of using small, low-budget projects to experiment with innovative ideas had demonstrated that one did not need big money or fancy materials to make great architecture. Gehry showed that if you had the ideas, you could find a way to express them. His pioneering ways had an impact on a group of rebellious but talented young Los Angeles architects—**Craig Hodgetts, Frederick Fisher, Thomas Mayne, Michael Rotundi,** and **Eric Owen Moss.** They did not fit into the parameters of any existing architectural school, but instead drew inspiration from a wide range of pop-culture

ABOVE
Gehry holding
a catalogue of
his *Easy Edges*
line of furniture

OPPOSITE
Cardboard chair
from Gehry's
*Experimental Edges*
line of furniture

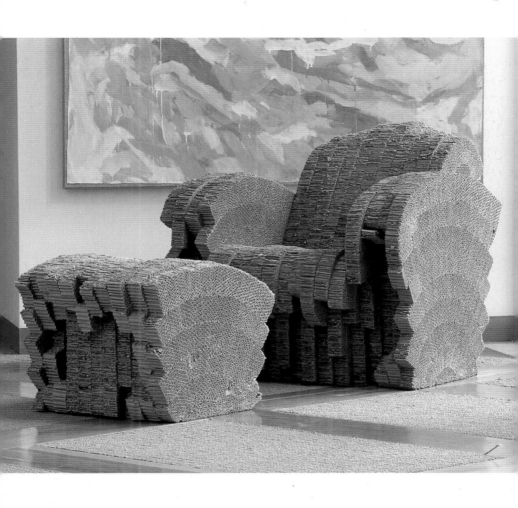

sources and pushed the limits by experimenting with offbeat materials and forms. In this regard, Gehry had become the spiritual godfather to this eclectic band of architects practicing what some simply called *L. A. Style*.

## Lured by fish

As Gehry explored new forms, he turned to fish again, a recurring image from his childhood that symbolized for Gehry the perfect blend of form and movement. In 1981, Gehry joined forces with sculptor Richard Serra in a show organized by the Architectural League of New York that featured imaginary constructions envisioned by architects working in collaboration with artists. Gehry and Serra designed a fantasy bridge that linked the Chrysler Building in midtown Manhattan to the twin towers of the World Trade Center downtown. The bridge was anchored by an enormous steel pylon (designed by Serra) that rose from the East River, and a 150-story fish (designed by Gehry) that leaped from the Hudson River.

The fish gained power as Gehry's special talisman when post-Modernism became the rage in the 1980s. The movement was defined

by geometrically shaped buildings that contained a fanciful pastiche of classical references—a Greek colonnade there, a Byzantine dome here. The idea of post-Modernism was to create a tension between past and present that raised questions about both historical periods. But the movement quickly degenerated into the architectural equivalent of a name-dropping contest in which the victor was the person who was able to cram in the most obscure references in a building.

As his language evolved, Gehry became fascinated not with creating ordered, colorful buildings but with designing structures that seem to capture the social tensions and incipient chaos of the time. His buildings are asymmetrical and an odd mix of materials, and have a certain unfinished quality to them, though they are often beautiful in their own way.

Fish Lamp

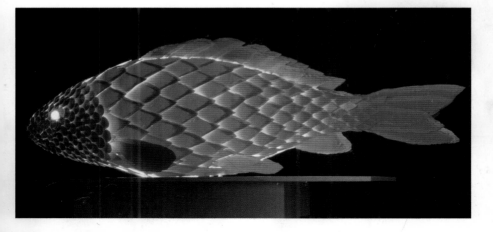

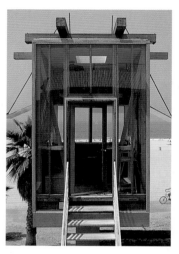

ABOVE
Writer's Study at
Norton House
Venice Beach, California

RIGHT
Norton House
Venice Beach, California

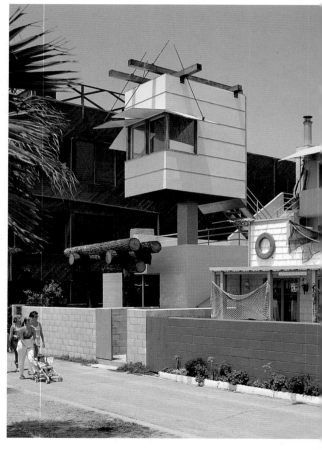

## Gathering momentum

In 1981, Gehry began work on the **studio-houses on Indiana Avenue** in Venice, California, then a mixed neighborhood of artists and blue-collar workers. Drawing on ideas he had used in his plans for the Jung Institute, the architect designed three boxlike structures—each with a living area, two-story studio, and rear garage—then placed them side by side on the narrow residential lot. He gave each building an identity by exaggerating one element (a large bay window in one; a chimney in another; a mock staircase in a third), then enhanced each by using a different sheath, such as green asphalt shingles, plywood, and sky-blue stucco. At first glance, each studio-house had its own integrity. But the longer you looked, the more all three begged to be read as a single dwelling, since Gehry had cleverly used the same rectangular windows in each building.

The same year, Gehry expanded his ideas in a plan to update the **Steeves House**, the Frank Lloyd Wright–inspired California contemporary he had designed in 1959. The new owners hired Gehry to design a large addition to the old house, but the Bel Air Fine Arts Commissions rejected his *village of forms*—which in this case resembled a miniature village of little dwellings—on the grounds that "it was not a house." Unfazed, Gehry pursued his vision in other projects. The design for the **Norton House** in Venice (1982–84) included among its components a freestanding writer's study designed as a lifeguard station, with a stunning view of the ocean.

OPPOSITE
Frances Goldwyn
Hollywood Regional
Branch Library
Los Angeles
California

BELOW
California
Aerospace Museum
Los Angeles
California

The **California Aerospace Museum** in Los Angeles boasts a post-Modern façade made up of an arrangement of diverse sculptural components that include a large metal-skinned polygon, a glass wall with a windowed prism above it, and a plain stucco cube with a hangar door.

In 1986, Gehry completed the luminous **Frances Goldwyn Hollywood Regional Branch Library** in Los Angeles, a veritable stack of pastel boxes that offers the viewer a dazzling play of light, both by day and by night.

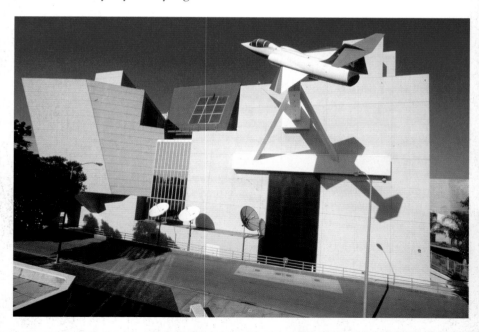

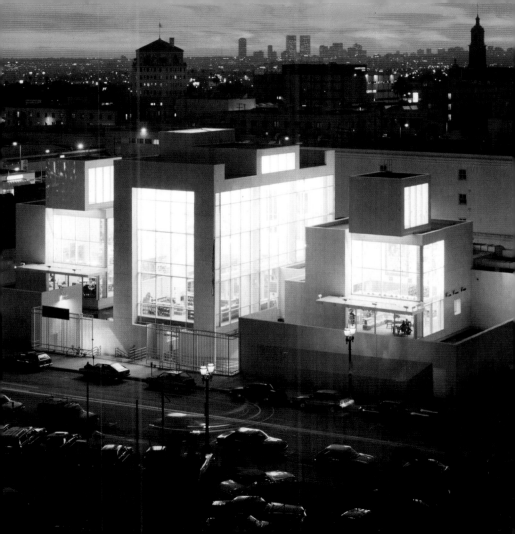

## Those Loyola lawyers

Gehry's most extensive use to date of his *village of forms* concept was the **Loyola University Law School** campus in downtown Los Angeles, not far from where Gehry had first lived as a teenager. The university required space for faculty offices, classrooms, a chapel, and lecture halls that shared a sense of identity with the industrial sites of the surrounding neighborhood. Gehry broke the project into several components. He renovated a narrow, three-story building, then created a miniature piazza out front, assembling around it numerous one-room buildings—a chapel, a lecture hall, an instructional hall—each of which had a distinctive shape and covering material. Gehry had recently been in Rome, and to reinforce the idea of *law* (Loyola was, after all, a law school), he incorporated around the piazza references to the ancient Roman Forum—a symbol of law—in the form of abstracted columns. As a final touch, he added a tree as a kind of Zenlike focal point to the piazza.

Loyola
University
Law School
Los Angeles
California

As successful as these designs were, Gehry realized that they essentially relied on standard architectural concepts—the axis, classical proportion, or the grid—to organize the disparate forms. For future projects, he wanted to push the envelope further. The inspiration emerged in his collaboration with the well-known Pop sculptor Claes Oldenburg, who transformed everyday objects such as baseball bats, tobacco tins, lipstick containers, and bicycle handlebars into gigantic, playful outdoor sculptures that subverted the very idea of official public monuments. In fact, Oldenburg's creations were dubbed *anti-monuments*.

Oldenburg and his wife/collaborator, **Coosje van Bruggen** (b. 1942), a Dutch art historian, were drawn into Gehry's orbit on a visit to the architect's Santa Monica house in 1982. Each was interested in the other's design strategies, and they began collaborating on projects. Among the more outlandish was *Il Corso del Coltello (The Course of the Knife)*, a performance piece of sorts that they staged in Venice, Italy, in 1985. It examined everything from theories of art to the cutting properties of Swiss Army knives, often in hilarious scenes. The trio wrote the script, designed and built the sets and costumes, then starred in the piece, which was staged alongside a canal. The grand finale featured a huge sculpture of a Swiss Army knife—complete with two blades and a corkscrew—that floated down the canal.

Claes
Oldenburg
and Coosje
van Bruggen
*Knife Ship I*
1985
Wood, steel
plastic coated
fabric, motor
h. 7' 7" (2.32m)
w. 10' 6" (3.2m)
l. 40' 5" (25.24m)

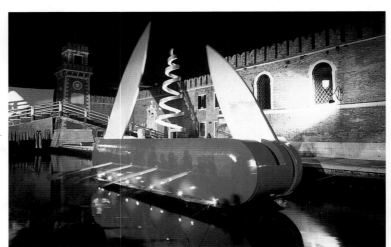

## Binocs to the rescue

As part of the skit, Oldenburg and Gehry designed a series of Pop Art works that were at the same time sculpture and buildings—including a gigantic pair of binoculars that served as a façade to a theater and a library. The big binoculars were never built, but Gehry kept a small model of them on his office desk back in California. They would come in handy the following year when he designed the corporate head-quarters for the trendy **Chiat/Day advertising agency** on Main Street in Venice, California.

Gehry broke the Chiat/Day (pronounced *Shy*-at Day) project into three connected buildings, but at first was able to work out shapes for only two of them: One was boat-shaped and the other resembled abstract trees. The third component—the middle section—gave him trouble. He wanted a more sculptural form, and, to demonstrate the idea, he picked up the model of the binoculars off his desk and dropped them into the project model. His client was astonished, since the binoculars fit perfectly.

The binoculars worked on several levels. They looked like Pop Art sculpture, caught your eye, made you smile, and led you to wonder what was going on here. They served as a metaphor for the advertising business, since, after all, it was about getting people *to see*. And they worked as architecture. Four stories high, made of concrete, and painted

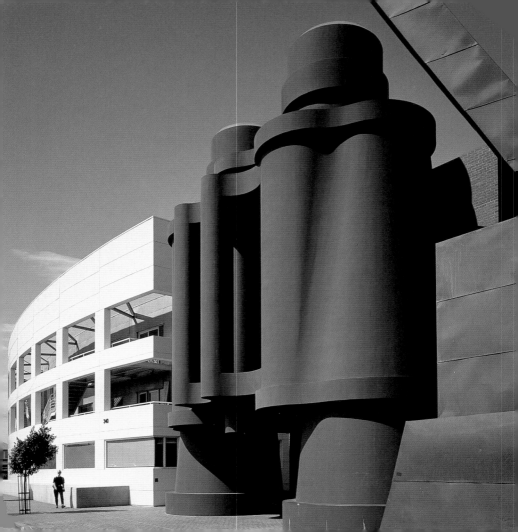

a matte black, they encased a parking garage on the street level, a dramatic lobby, and, on the upper floors, some discreetly placed conference rooms and skylights.

Although the three components—boat, binoculars, and trees—were laid out along a street front, they were locked into position not by grids or classical proportion but by the relationship of their shapes: Each fit alongside the other because of the way it was sculpted.

## Shaping up

Gehry ran with this idea of organizing components of a project by their sculptural shapes in his design for the **Winton Guest House** (1982–87) in Wayzata, Minnesota. The project called for a 2,500-square-foot guest house on a beautifully wooded 30-acre lot overlooking a lake. But the design was not to compete with the main house, a brilliant Mies van der Rohe–style brick box, designed by Philip Johnson in 1954.

Gehry worked through numerous ideas—including a plan that envisioned log cabins and tree houses—before realizing that they conflicted with Johnson's house. At the suggestion of the owners, he envisioned the guest house not as a traditional house but as form of abstract sculpture. Gehry broke the house into a series of rooms and gave each a geometric shape, then tightly grouped them around a towering pyramid form.

OPPOSITE
Chiat Day
Offices
Venice Beach
California
Building by
Frank O. Gehry
Binoculars
by Claes
Oldenburg
and Coosje
van Bruggen

# TWO SHINING STARS

The German-born designer **Ludwig Mies van der Rohe** (1886–1969) was known for his philosophy of less is more. He created contemplative, neutral spaces with simple materials and structural integrity, through which he achieved his vision of a monumental "skin and bone" architecture. Mies's residential designs, such as the Farnsworth House (1948–50) in Plano, Illinois, were radical outgrowths of the concept of the open plan, in which walls were used to define rather than enclose space. The result was an exceptionally dynamic interior flow.

**Philip Johnson** (b. 1906), then director of the architecture department at New York's Museum of Modern Art (MoMA), organized the first Mies van der Rohe visit to the United States. After Johnson left the museum to become an architect, he went on to become a leading proponent of post-Modernism and designed some of the world's most extraordinary (and controversial) structures, including The Glass House (1949), his personal residence in New Canaan, Connecticut, and the AT&T Headquarters in New York City (1978), with its so-called Chippendale Top. Over the years, he has not hesitated to change his architectural principles from Modernist to post-Modernist to anti-post-Modernist at will. Critics have faulted him for showing more interest in style than in substance, but he was nonetheless one of the 20th century's greatest stimulators of ideas in architecture.

The result, at first glance, looks like an oversized collection of Minimalist sculptures that border on Pop Art. Each form stands on its own but takes on a different meaning when viewed in relation to the others. That meaning changes as you walk around the forms. And it never conflicts with Johnson's house.

## Bigger and bolder

The Winton guesthouse won several awards, but this achievement was overshadowed in 1989 when Gehry won the $100,000 Pritzker Prize, the highest award an architect can win in his career. In explaining its choice, the Pritzker jury commended Gehry's maverick, risk-taking spirit and compared his relentless search for new forms to that of Picasso. The jury noted that while its award was traditionally given for lifetime achievement to an architect near the end of a career, it hoped Gehry would view the prize as "encouragement for continuing an extraordinary *work in progress.*"

Gehry used the prize money as a down payment on a house in Brentwood for his mother, then bought her a strand of pearls and got back to work. As a diversion, he resumed his teaching at Yale as the Charlotte Davenport Professor of Architecture.

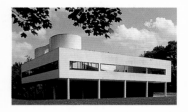

Le Corbusier. Villa Savoye
Poissy, France
1929–31

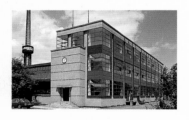

Walter Gropius and A. Meyer
Fagus Factory. Alfeld an
der Leine, Germany. 1911

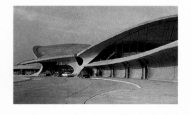

Eero Saarinen. TWA Terminal
JFK Airport, Queens, New York
1962

## ARCHITECTURAL STYLES OF THE 20TH CENTURY AND BEYOND...

You can't tell the players without a program, and that is especially true when it comes to architecture in the 20th century and beyond:

**International Style:** Sprang up in Europe in the 1920s and 1930s in response to the massive carnage of World War I. It sought to strip all decoration and historical references from architecture and to create a design that was beyond design— that is, a universal style that transcended time, place, and nations, and the tensions they created. The goal was to create an environment that would breed a new, cooperative human being, freed from the desire to make war. That, at least was the big idea. The actual results, honed and developed by such European architects as **Walter Gropius, Mies van der Rohe,** and **Le Corbusier,** gave rise to simple, geometrically shaped buildings of glass and steel, with plain white walls, bands of windows, and free-flowing interior spaces that were easily adapted to individual uses. The style gained popularity mostly in small houses, factories, and worker housing.

**Modernism:** Means many things to many people, but essentially it is best understood as corporate America's co-opting of the most profitable aspects of the International Style—simple, boxlike buildings made of glass and steel—and turning them into symbols of corporate efficiency and power in the post-World War II era. To that end, large architectural firms such as **Skidmore, Owings, and Merrill** gained worldwide success in

the postwar era by churning out with assembly-line efficiency endless boxlike, towering skyscrapers made of glass and steel and often surrounded by a spare, stone plaza. The style began in New York and Chicago in the 1950s and flourished through the 1960s. Many consider the buildings to be colossally ugly.

**Brutalism:** An initial reaction to the anonymity, boredom, and lack of emotion in Modernism. It began in the mid-1950s with Le Corbusier, who created a series of dense, expressive structures made of raw concrete that evoked curiosity and mystery, and that reflected the local context. The style, so called because of the *brute* (i.e., raw) nature of the concrete used and the feelings it generated, continued into the 1970s, mostly in the form of small buildings, private institutes, and civic complexes in emerging nations.

**Post-Modernism:** The best-known reaction to Modernism. It became the architectural rage in the 1980s and spawned countless offshoots throughout the 1990s. The post-Modernists sought to instill emotion—and, when possible, a note of wit and irony—into their buildings by adding pastel colors and abstracted references to classical architecture, often in exotic stone and brickwork as an acknowledgement of the local context. The movement hit the front pages in 1978 with the design by architect **Philip Johnson** for the AT&T Headquarters building in New York City. It crested with the design by **Michael Graves** (b. 1934) of the Portland Public

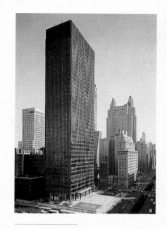

Mies van der Rohe
and Philip Johnson
Seagram Building, New York
1954–58

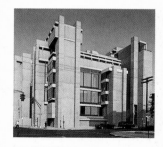

Paul Rudolph
School of Architecture
Yale University
New Haven, Connecticut
1961–63

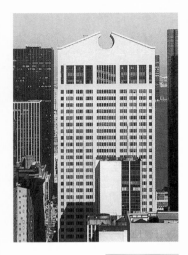

Philip Johnson and John Burgee
AT&T Headquarters Building
New York, NY
1978–84

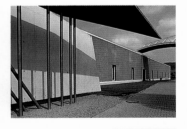

Zaha Hadid
Vitra Fire Station
Weil am Rhein, Germany
1993

Services Building (1980–82) in Portland, Oregon. **Richard Meier** (b. 1934), designer of the Getty Museum in Los Angeles, and the Italian architect **Aldo Rossi** (1931–1997), are examples of post-Modernist architects. The success of post-Modernism spawned countless imitators, and the style was quickly co-opted by consumer America for use in everything from cookie-cutter million-dollar mansions to Princeton University dormitories to Walt Disney World® hotels. It eventually wound up as the style of choice for shopping malls and mini-marts.

**Deconstructivism:** A response in the late 1980s to the neat, ordered, colorful, calm of post-Modern buildings that were rising in every suburb in America. The movement sought to draw attention to the destabilizing economic and social forces at work around the globe. Its followers *deconstructed* buildings by breaking them into parts, then reassembling those parts in ways that juxtaposed unusual materials, shapes, and designs. Their goal was to rethink concepts of space, time, and history. By looking at the component parts in new configurations, they maintained that one could get a better understanding not only of the *whole* but of the ideas behind the whole. If the buildings looked skewed and made you nervous, so much the better, since that malaise was now a fact of life in the age of global capitalism. Or so the deconstructivists thought. Despite a groundbreaking show at MoMA in 1988, the movement was consigned to architectural school models, academic forums, and museum exhibits until the late 1990s because of its difficult-to-build forms, academic flavor, disturbing shapes, and general unmarketability within the middle class.

**Hi-Tech:** A flamboyant style that gained popularity from the 1970s through the 1990s by emphasizing the technical aspects of a building, especially its structure and exposed service pathways—i.e., the air ducts, electrical outlets, wiring, and glass skin. The best-known hi-tech building is perhaps the Centre Pompidou (1971–77) in Paris, built by **Richard Rogers** (b. 1933) and **Renzo Piano** (b. 1937). The style gained clout in the late 1980s and 1990s as global capitalism adapted the movement's powerful imagery for megabanks, high-rises, and financial centers, especially in places like Hong Kong, and elevated architects such as **Norman Foster** (b. 1935) to worldwide attention.

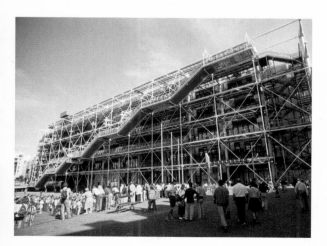

Richard Rogers
and Renzo Piano
Pompidou Center
(Beaubourg)
Paris, France
1972–77

## Pisces redux

Gehry loathed the post-Modernist movement and reasoned that if his colleagues were going back to ancient Rome to find *references*, then he would go back even further to the Paleozoic Era, when fish and reptiles ruled. Gradually, fish took on more significance as Gehry found himself sketching fish shapes whenever he got stumped in a design. Fish became his shorthand for something that was missing—and presumably unattainable.

**Sound Byte:**

> *"The fish shape got me into moving freely."*
>
> —FRANK O. GEHRY, 1990

The fish business got an unexpected boost when the Formica Corporation selected Gehry as one of ten architects to devise a use for its newest product, a uniformly colored plastic laminate, ColorCore. After researching the material with his usual thoroughness, Gehry discovered that the warmer ColorCore colors had a transparent quality that might make an interesting lamp. He tested the idea in some box-like lamps but eventually got so frustrated he threw one on the floor. The ColorCore broke into dozens of small shards that resembled, in Gehry's eyes, fish scales. So he started over with the lamps, piecing the shards together to create carplike fish structures, and captured a qual-

ity that had previously eluded him: the fish's appearance of effortless continual movement. Thus, the *Fish Lamp* (1983–86) was born. (It is shown on page 51 of this book).

## The Vitra Museum

Gehry's first big commission in Europe came in 1988–89 when he was invited to design the **Vitra International Furniture Design Museum and Factory** in Weil am Rhein, Germany, near the Swiss

Vitra
International
Furniture
Museum and
Factory
Weil am Rhein
Germany

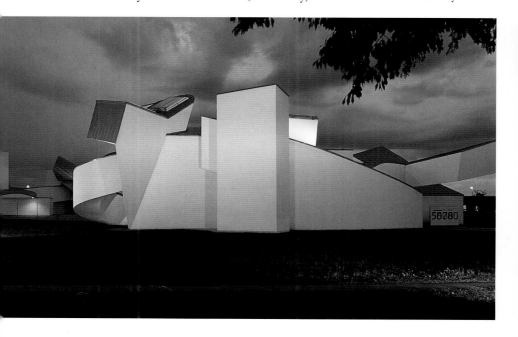

border. Rolf Fehlbaum, chairman of Vitra in the early 1980s, had admired some of Gehry's cardboard chairs from the 1970s. When Vitra—a manufacturer of office chairs—needed an 8,000-square-foot space to exhibit the firm's collection of 1,200 museum-quality chairs by such designers as Ray and Charles Eames, he contacted Gehry.

The architect broke his new project into three main exhibition galleries, each with a geometric form and a rakishly tilted skylight or clerestory window. He then connected the components with an abstract fish form: a sinuous curve that captured the fluidity of a fish in water and that pulled the composition together. For added impact, Gehry clad the entire building, sitting on a rolling green landscape, in white stucco, then trimmed the roof in zinc, which lent it a sculptural presence.

OPPOSITE
Four views
of the Vitra
International
Furniture
Museum and
Factory
Weil am Rhein
Germany

The flowing forms draw you around the building, while the tilted and skewed shapes make you stop and reconfigure the building as you go. Once inside, the sinuous curves turn into sweeping ramps that pull you through the galleries. Each gallery has its own distinct feel, thanks to a uniquely designed volume and source of indirect lighting, enhanced by overhead skylights.

The cumulative effect creates a sense that you've gone through the looking glass and entered a place beyond time and space where anything can happen. This feeling sets the mood for seeing the main attraction: hundreds of chairs on display, the prized artworks of Vitra.

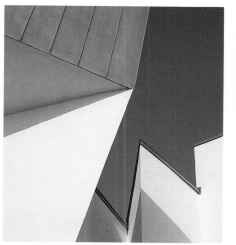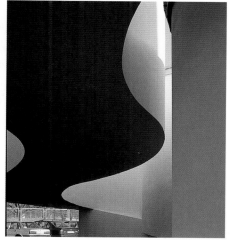
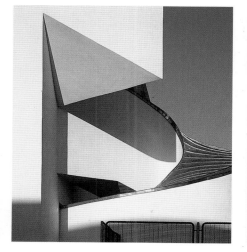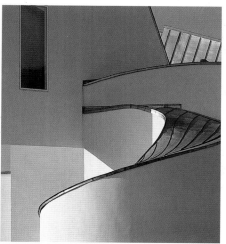

The Vitra Museum marked a turning point for Gehry. He had now discovered how to free the movement from the fish and extract the essence from the object. In the process, he opened up a limitless warehouse of imagery to choose from. The Vitra Museum opened on November 3, 1989, and, in its first year attracted 45,000 visitors to the otherwise little-known city of Weil am Rhein. It now has 55 employees and is a perfect marriage of economics and culture.

**Sound Byte:**
*"I don't know where you cross the line between architecture and sculpture. For me, it is the same. Buildings and sculpture are three-dimensional objects."*

—FRANK O. GEHRY, 1996

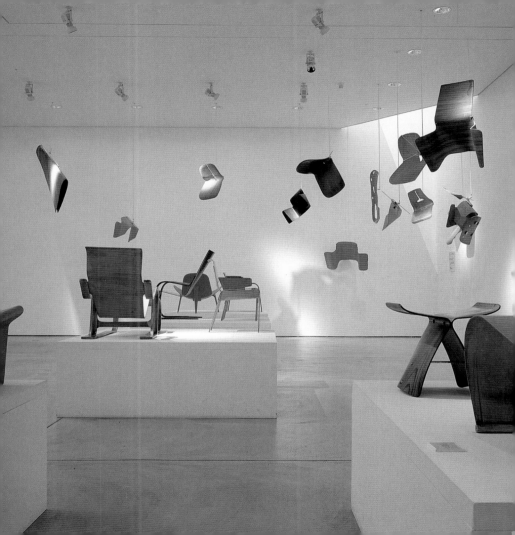

## Swoopy

The Vitra Museum pushed Gehry to another level, but to get there he had to take some unusual steps. In one sense, Gehry's imagination had become his worst enemy. He would come up with fantastic ideas for buildings, but would often meet insurmountable obstacles when trying to build them. Contractors balked, since they preferred to build box-like structures that had a cut-and-paste easiness to them. Fish bodies and double curves were difficult to achieve. Costly mistakes happened and that cut into the potential profits. For many contractors, it wasn't worth the risk.

## Invasion of the computer geeks

So in 1989, Gehry brought the architect/computer maven **Jim Glymph** into the firm to find a cost-effective method for building complex

LEFT TO RIGHT

A
CATIA enginneer tracing model for digital imput

B
Surface model is created from digitized points

C
Shaded surface model is created

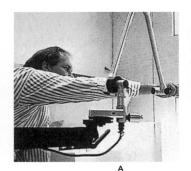

A

B

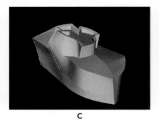

C

designs. After a long search, Glymph discovered **CATIA** (Computer-Assisted Three-dimensional Interactive Application), a computer program that the French aeronautical firm Dassault Systèmes had designed to build Mirage fighter jets.

For Gehry, the genius of CATIA was that with it he did not have to use a computer, but could scribble out preliminary sketches, then work out his ideas in endless paper and cardboard models as he had always done. At this stage, his colleagues could take over and handle the computer aspects of his designs.

Here's how CATIA works. Once Gehry has created a model, CATIA scans the hand-built model, translates the information into working drawings, and provides a computer diskette that contains detailed specifications for suppliers (e.g., it gives stone quarries quantitative information on how to cut the stones for a project).

LEFT TO RIGHT
**D**
CNC fabricated milled model from digital model

**E**
Secondary structure created

**F**
Finished building

D

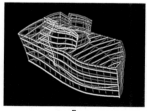
E

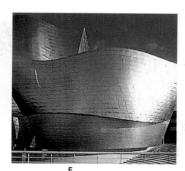
F

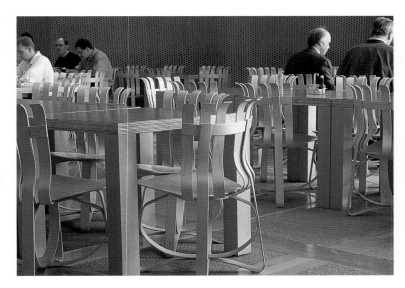

Bentwood
chairs in
cafeteria of
EMR
Communication
Center
Bad Oeynhausen
Germany

Gehry first tested the program in an enormous fish sculpture (what else?) for **Vila Olimpica**, a hotel/shopping/office complex designed in 1992 in Barcelona, Spain. His office had a tight budget and less than a year to realize the 177-foot-long x 115-foot-high sculpture, but they did it, thanks to CATIA—and with impressive results. The enormous abstracted-fish form made of woven copper-colored metal strips hovers magically above the waterfront shopping complex like…a fish out of water.

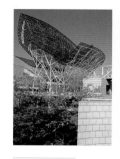

Fish Sculpture at Vila Olimpica Barcelona, Spain

## The Gehry Way

More than one visitor to Gehry's Santa Monica, California offices has been amazed to discover that the facility looks more like a sprawling workshop for Santa's elves than the august headquarters of one of the world's most respected architects. But that's no accident. Gehry has long prided himself on being a "hands-on" architect. He works out his ideas in endless models and his staff of 130 reflects his approach: Most are engaged in building and rebuilding to Gehry's satisfaction the models of various projects that are currently in the works. As a rule, a "Gehry project" goes through several stages. He collects all the information he can about the project's requirements and the client's needs, does a quick sketch of an idea, then begins to model. The first models are basic: Simple wooden blocks are used to represent each component part of a given program, such as the bedroom, living room, office, conference room, etc. The blocks are then assembled and reassembled

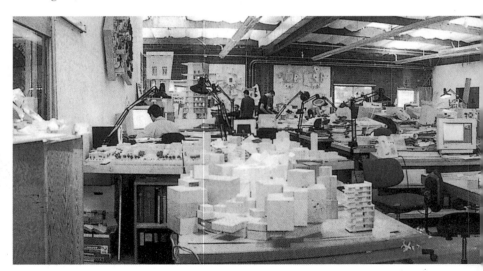

until Gehry thinks they look right. At that point, Gehry sculpts forms around the blocks, using everything from paper to tinfoil and even red velvet. He compares the process to that of a sculptor pulling and pushing a lump of clay to find the shape in it. As part of the process, Gehry builds the project in several different scale models to see how his ideas are working out. If a full-scale mock-up of a window or a booth is needed, he'll do that too.

Once the final model is complete, CATIA translates Gehry's strangest shapes into buildable drawings, and has the capacity to generate instructions that tell manufacturers how to cut a sheet of metal to cover a roof shaped like a rolling wave.

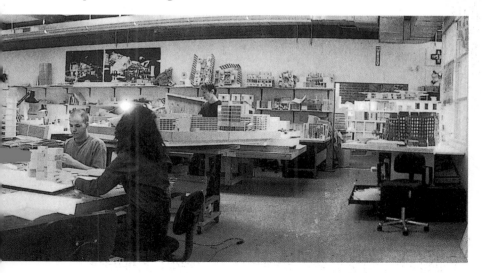

## Pushing on

The success of Vila Olimpica spurred Gehry's imagination and gave rise to a whirlwind of remarkable buildings in the 1990s. In 1992, he finished work on the **University of Iowa Advanced Technologies Laboratory** in Iowa City, and, in the same year, designed the **University of Toledo Center for the Visual Arts** in Ohio.

In 1993, Gehry completed work on the **Frederick R. Weisman Art Museum** on a bluff overlooking the Mississippi River in, Minneapolis, Minnesota. Inspired by the shape of a sail fluttering in the wind, he designed an undulating stainless steel façade that provided windows looking up and down the river, and sculptural skylights that indirectly lighted the spacious galleries inside.

OPPOSITE
Frederick R. Weisman Museum of Art University of Minnesota Minneapolis

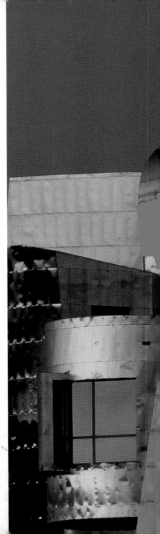

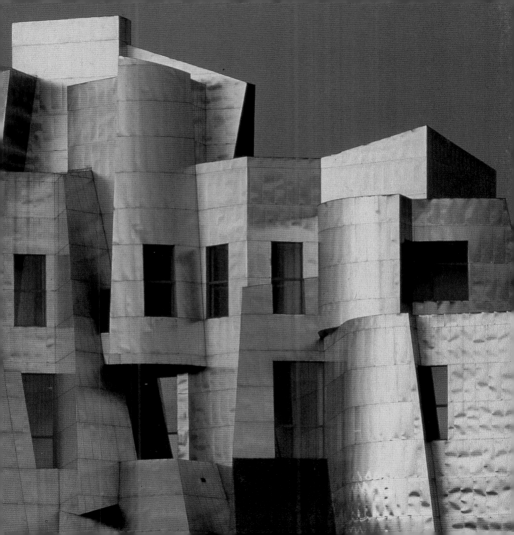

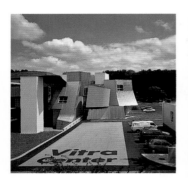

Vitra International
Headquarters
Basel, Switzerland

The same year, Gehry distilled the essence of a rolling ocean wave to create a striking roof for the **Disney Community Ice Center** in Anaheim, California. In 1994, he created the **Vitra International Headquarters** in Basel, Switzerland, and, a year later, the **Team Disneyland Administration Building** in Anaheim, California.

## Shall we dance?

In 1995, Gehry completed work on an exuberant structure in Prague, Czech Republic, that evokes the dancing grace of film stars Ginger Rogers and Fred Astaire. Its formal name is the Nationale-Nederlanden Building, but it has been dubbed the **Ginger & Fred Building**, since—like the eponymous stars—it seems to be dancing merrily along the Vltava River. The main façade, dotted with staggered windows, overlooks the river and is a horizontal variation on the adjacent windowed rowhouses. The corner of the building comprises two round towers: The "Fred Astaire" tower is solid and cylindrical, while the "Ginger Rogers" tower is glass-enclosed and tapered. Gehry erected

**Sound Byte:**
*"The shapes of my buildings have to be clearly related to what is going on inside them. It is a misconception about my work that I just make shapes and that there is no inside. People say that all the time. I don't know how they see that or get that idea."*
—FRANK O. GEHRY, *Architectural Record*, December 1998

the structure on a site where an American bomb during World War II had accidentally destroyed a building. Gehry's undeniably post-Modern, deconstructive signature stands in marked contrast to the building's historic setting. The *catastrophe architecture* of the building appears to repeat the destruction of the cityscape on this site.

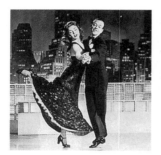

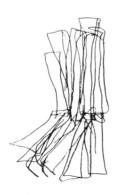

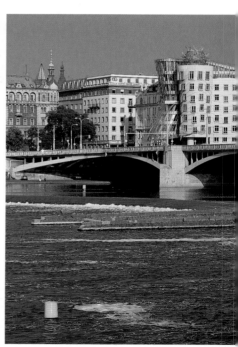

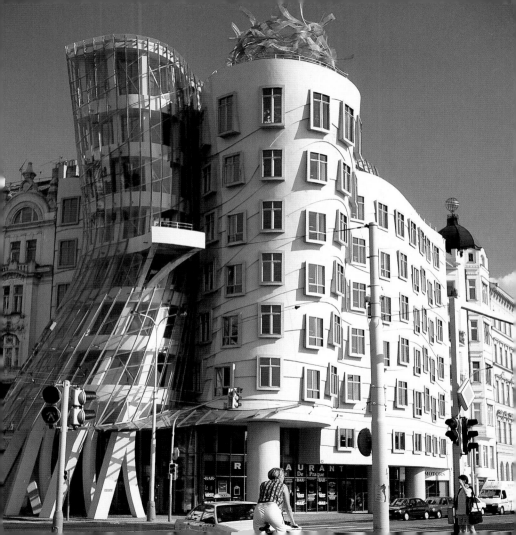

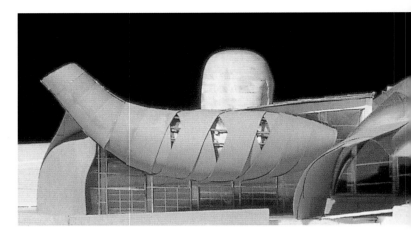

## The house that grew & grew

One of Gehry's most interesting projects—begun in 1987 and abandoned nine years later—was the **Peter Lewis Residence**. An insurance millionaire from Cleveland, Ohio, Lewis had heard Gehry lecture in 1985 and immediately lured him with an offer: "How'd you like to do the greatest house you've ever done?" Gehry began the project with a plan to renovate Lewis's existing house, located on a nine-acre site next to a golf course in a Cleveland suburb. Then he changed gears and decided to knock down that house and build another structure of 22,000 square feet, which eventually mutated into a 40,000-square-foot megaproject with an $80 million price tag.

The on-again, off-again commission turned out to be one of the most significant in Gehry's career, given the lessons he learned from it. His initial design in 1987 reflected the *village of forms* strategy and created a series of geometric shapes arranged around a courtyard that featured an enormous sculpture of a coiled snake. By the third version, in the summer of 1993, Gehry's growing fluency with CATIA enabled him to create a sculptural design with individual rooms swirling around a vast, glass-enclosed living room that bubbled up in the center of the project like a fountain.

At some point in the process, Lewis decided to turn his house into a museum so that he could leave it to the city of Cleveland upon his death. That sent Gehry back to the drawing board, with a considerably enlarged plan to add space for galleries, curators, and storage.

Along the way, Lewis involved a number of major artists—Claes Oldenburg, Frank Stella, Larry Bell—in the project, along with architect Philip Johnson. They provided a slew of ideas that Gehry worked into—and out of—the design. Alas, the project was never built, since Lewis could never decide what he wanted or how much to spend.

## An important lesson

Gehry's astonishing commitment to the Lewis Residence generated a wealth of ideas, forms, and materials that would eventually wind up in his other projects. By the time he had reached the final Lewis model, Gehry had found a way of seamlessly unifying his irregular shapes, even though it happened by accident: At one stage, stumped by trying to unify so many strange shapes, Gehry had draped a piece of red velvet across the model. The material tied everything together, like a mountain stream winding around boulders and rocks. Gehry worked with the shape, spraying wax on the velvet and molding it, and eventually had it scanned into CATIA and added the finishing touches to the unifying shape.

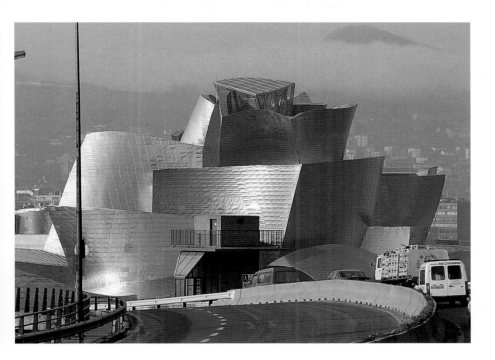

## Crushing the box in Bilbao

This discovery would pay huge dividends when Gehry began work on what would become his most famous building to date, the **Guggenheim Museum in Bilbao, Spain** (1991–97). The aging port city on the north coast of Spain was looking for a major attraction that would put it on the map as a tourist destination. At the same time,

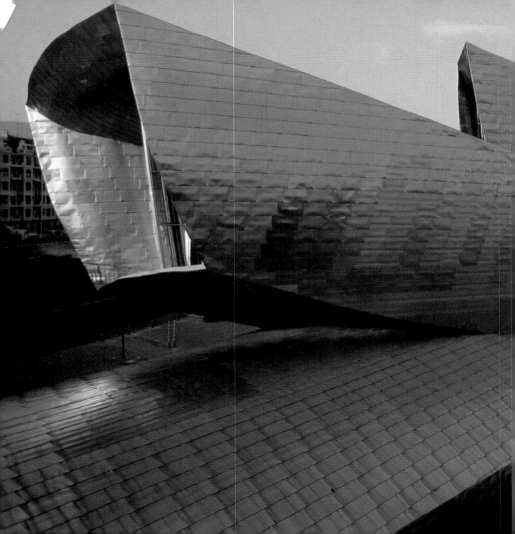

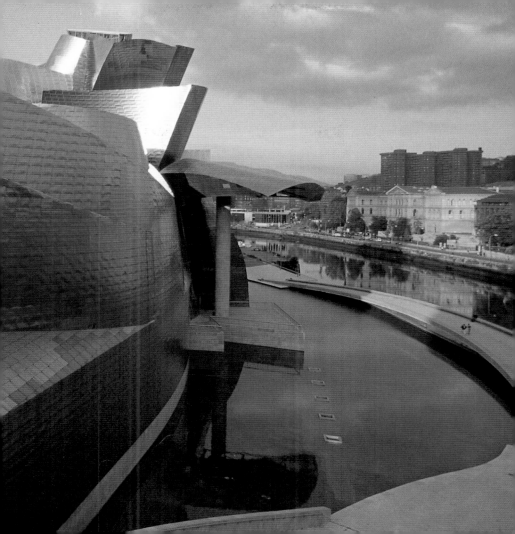

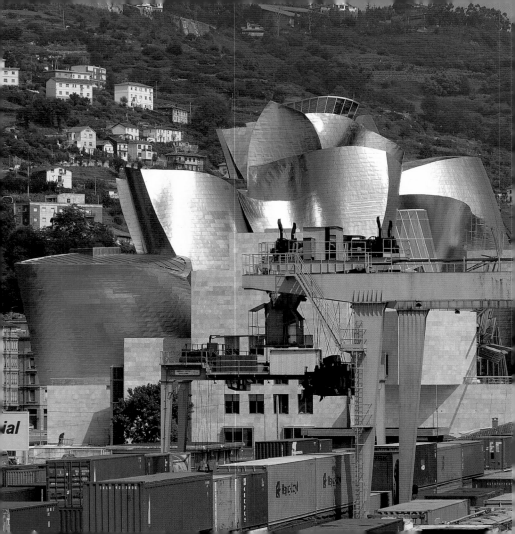

Guggenheim director **Thomas Krens** was seeking an opportunity to expand his museum's presence around the world. Gehry was selected over three other architects, in part because he proposed a plan that would move the museum from its suggested downtown site to a deserted industrial area of the city along the Nervión River. There, Gehry reasoned, his design would connect the existing 18th-century city to its lost heritage as a once-thriving port.

## And the envelope, please?

Gehry's design featured a 400-foot-long gallery and 19 others of varying sizes that radiated out from a central soaring atrium and spread into a variety of formidable shapes hovering over a limestone base. One minute, the building looks like a gigantic Minimalist sculpture; the next, a melting ocean liner or a rose with unfolding

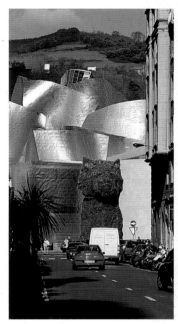

ABOVE AND LEFT
Guggenheim Museum
Bilbao (Notice Jeff Koons'
*Puppy* in image above.)

OPPOSITE PAGE
Guggenheim Museum
Bilbao within the context of
its industrial neighborhood

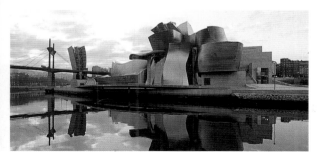

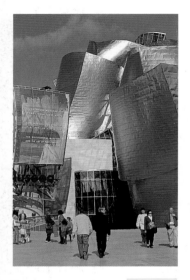

petals. It is all part of the same twisting, restless building, of course. But it's impossible to grasp the structure from one angle alone. Only by walking around it and experiencing this *object* at firsthand and watching the shapes morph can you appreciate this museum that is like no other in the world.

The building's titanium *skin*, or sheathing, is so thin it ripples and wheezes in the wind, creating the impression that the building is somehow alive and breathing. What's more, the titanium changes colors throughout the day, ranging from gray-blue in the early morning, to buttery gold at noon, to a strangely mysterious bronze by night.

To enter the museum, you walk down a gradually sloping ramp and pass through the low-lying entrance into a soaring atrium that rises some 15 stories. It is crisscrossed by catwalks, enclosed-glass elevators, and stairs that bend at impossible angles. The interior, bathed in white, is accented with honey-colored stone and green glass. Visitors experience a sense of euphoria and a desire to explore further. The immense gallery next to the lobby—approximately 425' long x 100' wide x 85' high—contains no central supports. This allows for the

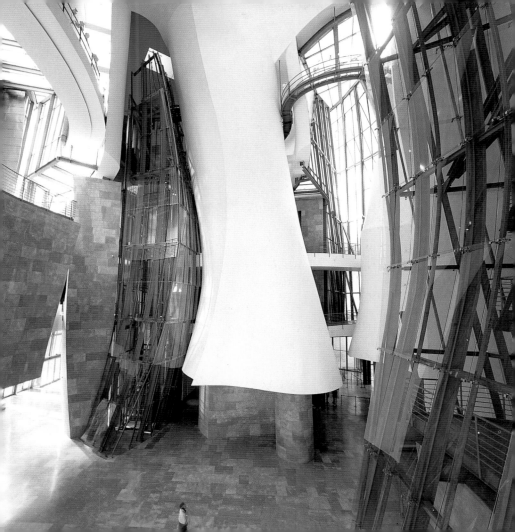

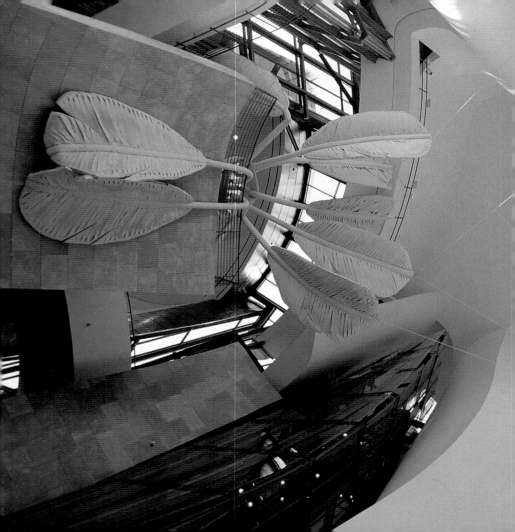

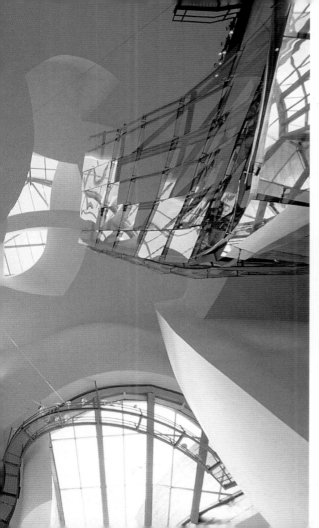

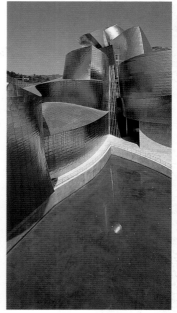

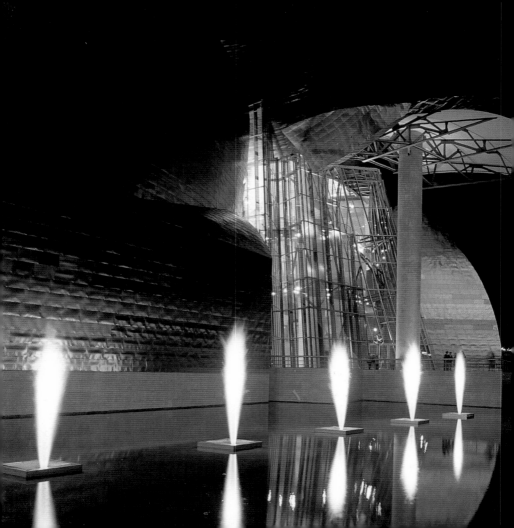

exhibition of enormous sculptures, as if an outdoor gallery had moved indoors. More wonders and pleasures await the visitor on the floors above.

Remarkably, Gehry's design offers dozens of "forbidden pleasures" by enabling a series of eye-opening experiences. His architecture pulls you gently through the space and frames the works of art on display. But whereas most architects and museums stop there—i.e., getting you to see the art—Gehry takes you further: He juxtaposes the architecture and the art on the walls to create an amazing visual dialogue that prompts you to examine the very nature of *seeing*. When you enter a gallery, you might see a Rauschenberg on the wall, then glance right to catch a glimpse of the street through an oddly slashed window that itself looks like a painting. This leads you to unconsciously compare the Rauschenberg and the framed street scene.

It was hoped that the 256,000-square-foot Guggenheim Bilbao would draw 500,000 visitors a year, but it draws nearly twice that number. The panache and attention received by the museum have increased Gehry's profile and demand for his work. It seems that every town wants a "Gehry" of its own.

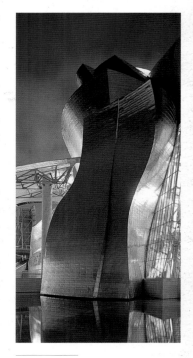

ABOVE AND OPPOSITE
Night Views of
Guggenheim Museum
Bilbao

## Let there be music

OPPOSITE
Guitar Tower
Experience
Music Project

Equally arresting is Gehry's design for the **Experience Music Project** (the **EMP**) in Seattle, Washington, which opened in the spring of 2000. EMP is still best known for being what it isn't: the Jimi Hendrix Museum. It is the brainchild of Microsoft billionaire **Paul Allen** (b. 1952), a rock-'n'-roll fan and passionate admirer of Seattle-born guitar legend **Jimi Hendrix** (1942–1970). Hendrix had been famous in the 1960s for psychedelic songs such as "Purple Haze" and "Wild Thing"—anthems for his generation—and for smashing his Stratocaster guitar to bits on stage. He had believed that music could become a "Sky Church"—i.e., a universal language for bringing diverse peoples together—and the 139,000-square-foot EMP was intended to realize that goal. Allen's original idea was to create a small museum from his Hendrix memorabilia collection, but Hendrix's family would not agree to the use of his name. Never a quitter, Allen enlarged the project exponentially and brought in Frank O. Gehry and Associates.

LEFT
Paul Allen and
wife Jody Allen at
opening of EMP

RIGHT
Frank O. Gehry
at opening
of EMP

The venture was a departure for Gehry. He knew little about rock-'n'-roll music, and less about Hendrix. But thanks to two architects on his staff—Craig Webb and Jim Glymph, who both played in rock bands—Gehry was quickly brought up to speed.

The often-enigmatic Gehry has said that the design is based on a smashed guitar, but, as journalist Randy Gragg noted on April 11, 1999, in *The Oregonian*, "the model for the building suggests something closer to a guitar as seen by somebody who is smashed." It is an undulating, metal-clad structure that wraps around the Monorail at

Experience
Music Project
Seattle
Washington

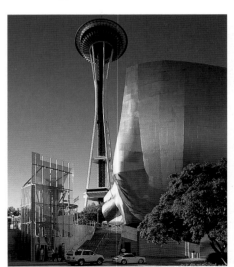

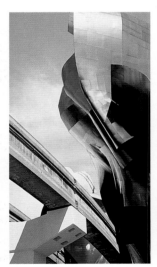

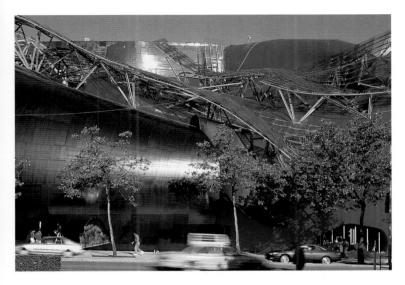

the base of Seattle's Space Needle and is shaped a bit like an ice cave. The curvaceously rolling building has scarcely a single right angle. As EMP's project manager, Paul Zumwalt, put it, "If there's something straight, we know we got it wrong."

Gehry evolved a design that broke the program down into six general areas: a multimedia center called **The Artist's Journey**; a large gathering space called **Sky Church** that features the world's largest video screen; three exhibit spaces; and a restaurant. Each has its own distinctly fluid shape (as opposed to Gehry's previous geometric forms)

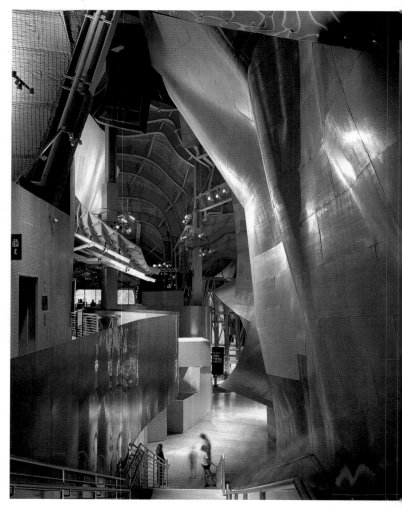

Experience
Music Project
Seattle
Washington

and is linked to the others under a flowing sculptural roof. Each of the six areas is sheathed in a brightly colored enamel aluminum (red, gold, purple) that catches and refracts the light differently throughout the structure, creating a kaleidoscopic effect.

At the same time, EMP physically embodies the ideas of Hendrix and his dream. The building's six parts can be read as the giant remains of a smashed Fender guitar. They unite around the tallest piece, the purple-colored building that houses Sky Church. From this towering meeting place, visitors begin their journey inside the museum, entering through **Purple Haze** into the mind and music of Hendrix. The EMP, a kind of West Coast rock-'n'-roll museum, has been a meteoric success.

Aerial View of Experience Music Project Seattle Washington

## Der Neue Zollhoff

An area that remains a new frontier for Gehry is the skyscraper. Even though he has designed many of them—and has created interiors for many of them, such as the cafeteria at the Condé Nast Building at One Times Square in New York—he has yet to build one. The closest he has come to doing so was in 1999 when he completed work on an office complex, **Der Neue Zollhoff** (The New Customs House), in downtown Düsseldorf, Germany. The project called for 300,000 square feet of office space along the Rhine River, where redevelopment efforts were converting old warehouses into cultural and media spaces. Gehry's structure was not permitted to block views of the river, especially from the surrounding buildings. Gehry's design divided the concept into three buildings—A, B, and C—and then broke each of them into clusters of small hi-rises, with the tallest being 13 stories. Each cluster stands on its own and has a distinct style. Building A is clad in white stucco; Building B, in brilliantly polished stainless steel; and Building C, in red brick. The buildings are cleverly linked by the windows: Each building features the same quirky, rectangular windows made of dull steel that angle out distinctively and thus cap the design. Gehry calls the creation his "anti-Rockefeller Center."

THIS PAGE
Der Neue
Zollhoff
(The New
Customs House)
Düsseldorf
Germany

OVERLEAF
Gehry
contemplating
his architectural
model of
Der Neue
Zollhoff
as viewed
from the
opposite side of
the complex
shown on
page 107

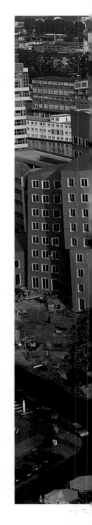

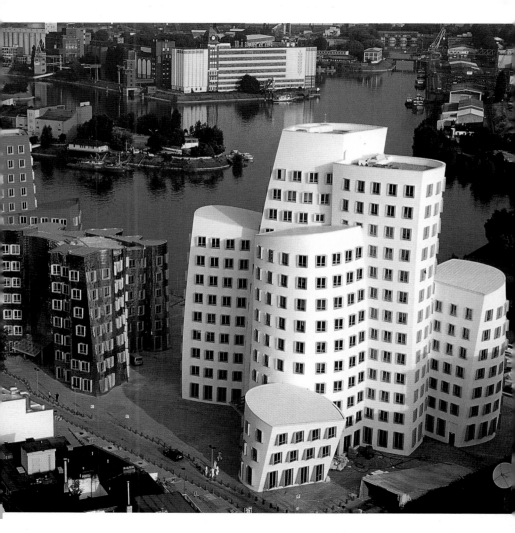

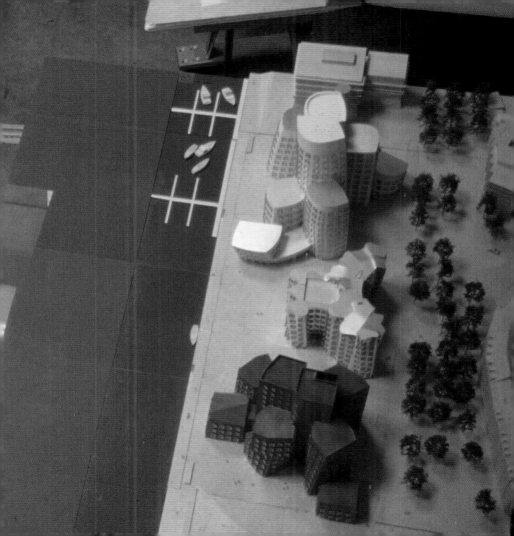

## Guggenheim, New York

The project that is raising eyebrows everywhere is the plan—announced in the spring of 2000—for a new Guggenheim Museum in lower Manhattan. Thomas Krens, the Guggenheim director who brought us Guggenheim Bilbao, has retained Gehry to create a vast structure that will house some 36 galleries, more than 500,000 square feet of exhibit space, and a gamut of ancillary activities—including a 1,200-seat theater, an education center, and a vast ice rink.

The proposed structure would be four times the size of the Guggenheim Bilbao and would occupy roughly the equivalent of ten city blocks. A major challenge facing Gehry is the prospect of fitting such an enormous structure into Manhattan, a city packed with skyscrapers—and zoning laws!

Gehry's design draws on his tested strategy, perfected in Bilbao, of placing the museum on the edge of the city, so that it invites comparison with nearby city buildings but does not clash or detract from them. To that end, he has situated the museum just off the FDR Drive on the lower East Side, on three piers in the East River that look like giant lily pads.

He foresees a complex comprised of numerous components, massed fluidly throughout the site, then wrapped in titanium that seems to swirl through the project like a silver cloud, creating a sense of wonder.

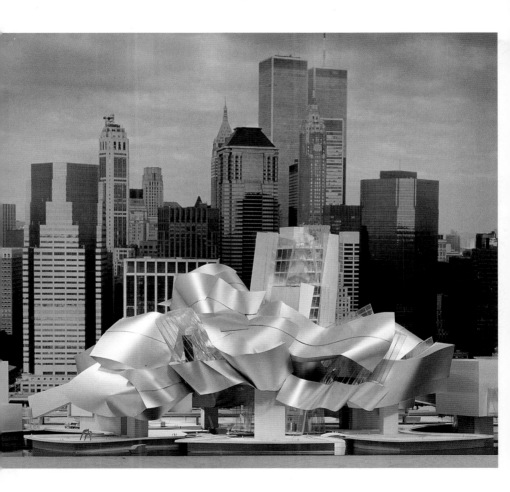

## And so?

During his 50-odd-year career, Gehry has repeatedly bucked the architectural trends of his time, as if using architecture to proclaim: *Oh yeah?* He has built homes, offices, and museums in the form of boats, clouds, a lifeguard station, and has even inserted a giant pair of binoculars into one of his buildings. He has constructed beautiful structures with "cheapskate materials"—plywood, concrete blocks, corrugated metal, and chain-link fencing—and he has done so on low budgets, guided by a belief that it's not the money or materials that count, but how you use them.

While some people view his buildings as dissonant, slightly junked-up structures that mirror a dysfunctional society, others consider his designs paragons of pleasure that glow with a desire to express new forms through change. Next time you see a Gehry building, see whether you smile or frown. Either way, you'll have a reaction—and that would please Frank O. Gehry.

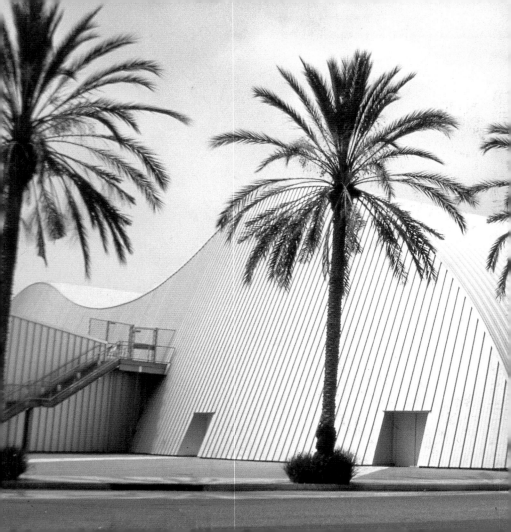